Layout and Composition for Animation

Ed Ghertner

Routledge
Taylor & Francis Group

LONDON AND NEW YORK

First published 2010 by Focal Press

This edition published 2015 by Focal Press

Published 2017 by Routledge
2 Park Square, Milton Park, Abingdon, Oxon OX14 4RN
711 Third Avenue, New York, NY 10017, USA

First issued in hardback 2017

Routledge is an imprint of the Taylor & Francis Group, an informa business

Library of Congress Cataloging-in-Publication Data
Application submitted

British Library Cataloguing-in-Publication Data
A catalogue record for this book is available from the British Library.

ISBN 13: 978-1-138-40313-0 (hbk)
ISBN 13: 978-0-240-81441-4 (pbk)

For Jana, Sean, and Amy

Acknowledgments

The journey to bring this book to reality is a long one and my purpose is to pass along the knowledge that was given to me. I wanted to explain and show that the Layout Artist's contribution to the animation process is extremely important and that 2-D Animation, as an art form, should not be thrown away like an old shoe for the sake of progress. I know that each step of the animation process, from story to final color, will change due to progress and innovation; however, knowing and passing on the history and evolution of those processes are important to the future of this great art.

There are many friends, colleagues, and neighbors who inspired me and supported me along the way in creating this book. There are a few I'd like to acknowledge in print: my parents, Elliot and Carole; my wife, Jana, whom I haven't seen much of while writing this book; my kids, Sean and Amy; the rest of my immediate family, both here and gone. I also want to thank the artists who taught me: the great Ken O'Connor, Don Griffith, Maurice Noble, Mike Maltese, Bill Moore, Vance Gerry, and last but not least, Eric Larson. Without their selfless characters, I would have lost hope. To my friends Brian Efron, Mark Kirkland, Brian McEntee, Krista Bunn, and Karen Bunn, thank you for being there and for your support.

A special thank you to Karen Bunn who took on the daunting task of helping me lay out the book, and without whom I would have never made the schedule. THANK YOU!!!!

The information in this book is dedicated to those who wish to learn and advance themselves in a truly beautiful art form.

Long Live Animation!!!!!

--Ed

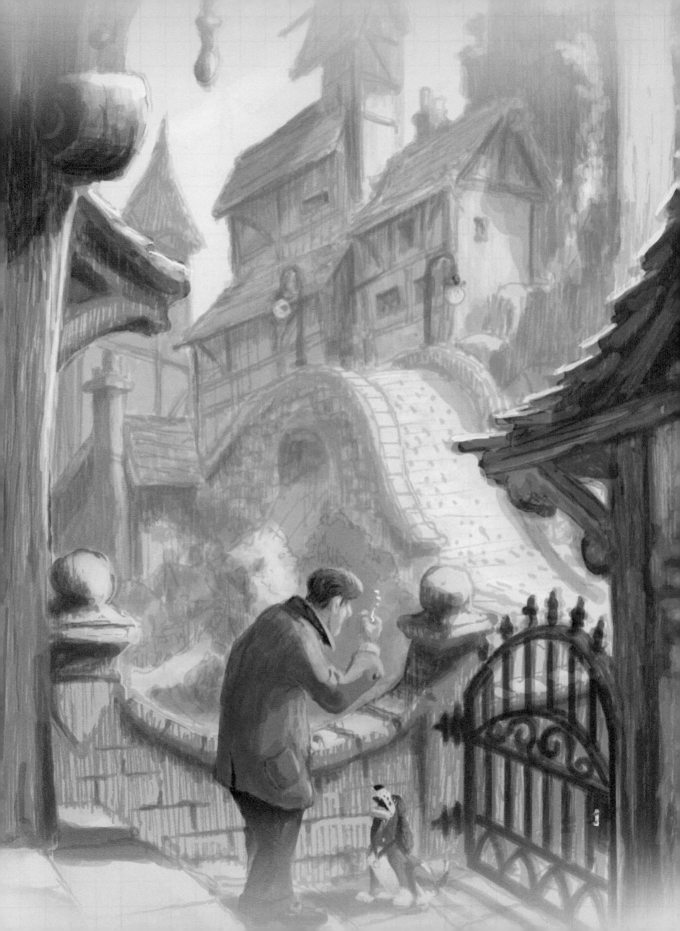

Table of Contents

Intro
Once Upon a Time...

In this book, I will begin with the premise that all things have a story. You, me, the chair I'm sitting in, the tree outside my window, the squirrel in the tree, the nuts in the squirrel's cheeks. All things have a story, and all stories of all people, places, and things interact and influence each other.

In animation, while it might seem to some that the interaction between characters drives the story of the film, the characters are also constantly interacting with the world in which they live. They walk through it, they touch it, it can hold them back, and it can propel them forward. That world and its story are what layout artists create. To do that properly, it's important to recognize that since all things, animate and inanimate, have a story, they must also have their own unique composition and perspective. The nuts and bolts of how to do this are the primary mission of this book. However, there is a deeper reason — a storied reason.

In the last decade, the business of animation has changed its composition and perspective. It has gone from a small centrally located industry with a few major players, to a worldwide industry with many producers of animated product, both small and large scale, 2-D and 3-D. Young kids at home can create their own animation and post it online. Television and feature animation is designed in one place and animated in another far across the planet. Art that was once meticulously drawn by hand with paper and pencil is now created directly in a computer environment that can

be set up to employ artists who will work together, but never meet face-to-face. Artists move from one production company to another, sometimes spending only mere days or weeks in one place. The entire industry and its older, experienced artists have been decentralized, scattered to the winds, making it less possible for them to interact with and mentor young up-and-coming artists as was done years ago. While I applaud and hope always for the growth of this industry, I often feel sorry that this mentoring process has become a relic of time past.

It is precious to me. It is part of my story:

Once upon a time, I was a tall, gangly teenager being raised in the North San Fernando Valley. I had been drawing almost from the moment I could hold a crayon. This was a while ago, in a time before videotape or DVDs were available; however, my family was privileged as my grandfather worked at The Walt Disney Studios in the transportation department. For my sisters and me, he was able to borrow a 16mm print of one of the Disney features to show at each of our birthday parties every year. This added to the obsession. All I wanted was to work in the animation industry.

© Disney Enterprises, Inc.

Intro
Once Upon a Time...

When I was a freshman in high school, I made a call to Don Duckwall, the man in charge of Disney Animation, and was soon introduced to an animation wizard named, Eric Larson, who said he help me put together a proper portfolio.

Knowing full well who Eric Larson was (his name was all over the movies and books I adored) and shakily armed only with a satchel of disorganized quick sketches, I found myself sitting face-to-face with him one afternoon. Eric asked me to show him my drawings. He took one of my sketches, threw another piece of paper over it on top of a light table, and began to draw explaining what he was doing as he went. It was magic.

I watched how his hand moved over the paper. He had such flair with the pencil. In just the first few movements, my weak drawing became a strong, sculpted pose. Then Eric cast his spell on another of my drawings, and another, and another, and with each subsequent drawing my work came more to life. After two hours of this, my brain hurt. I was overwhelmed, but what he'd shown me sunk in. It is well known that Eric was not only a master artist; he was an incredibly gifted and generous teacher.

At the end of our time together, Eric said he thought I'd be a good candidate for CalArts, which was an art school established by Walt and Roy Disney in 1961. He said that when I turned in my portfolio there, to tell them that the Studio recommended me for the animation program. I was in seventh heaven. For a year and a half,

I worked on my portfolio using all the tools Eric had given me that day. I turned in a very respectable portfolio to CalArts for review and was not only accepted, but was given a scholarship to enter the program. This was not due to just my talent alone, but also, I believe, to the sage advice I'd received from Eric Larson that afternoon a year and half before.

In school and throughout my career I've had the opportunity to work with and learn from Ken O'Connor, Maurice Noble, Mike Maltese, Don Griffith, Marc Davis, Ward Kimball, Joe Grant, Jules Engel, and, as you already know, the great Eric Larson. I am indebted to them all.

There are many naturally talented young artists working in the industry today. I meet them all the time. But for all their talents, certain skills regarding composition, perspective, and camera movement are sometimes lacking, perhaps because they haven't had the kind of mentoring I was so privileged to receive. I've found that if I take just a little time to sit down with them and show them the secrets I've learned in my career, they quickly become much stronger in their craft.

So this teaching book is my opportunity to do for those artists what was done for me. To pass on what I know from my experience and from the magic of some rare and wonderful mentors. It is the only way I know how to pay them back for their contributions to my story.

I hope this book contributes to yours.

--Ed Ghertner

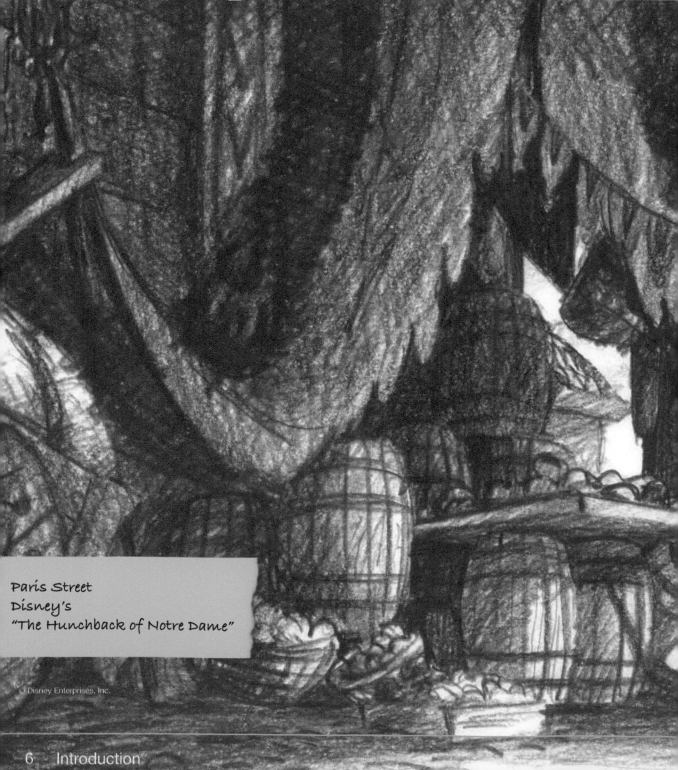

Ghertner's Gallery

Paris Street
Disney's
"The Hunchback of Notre Dame"

© Disney Enterprises, Inc.

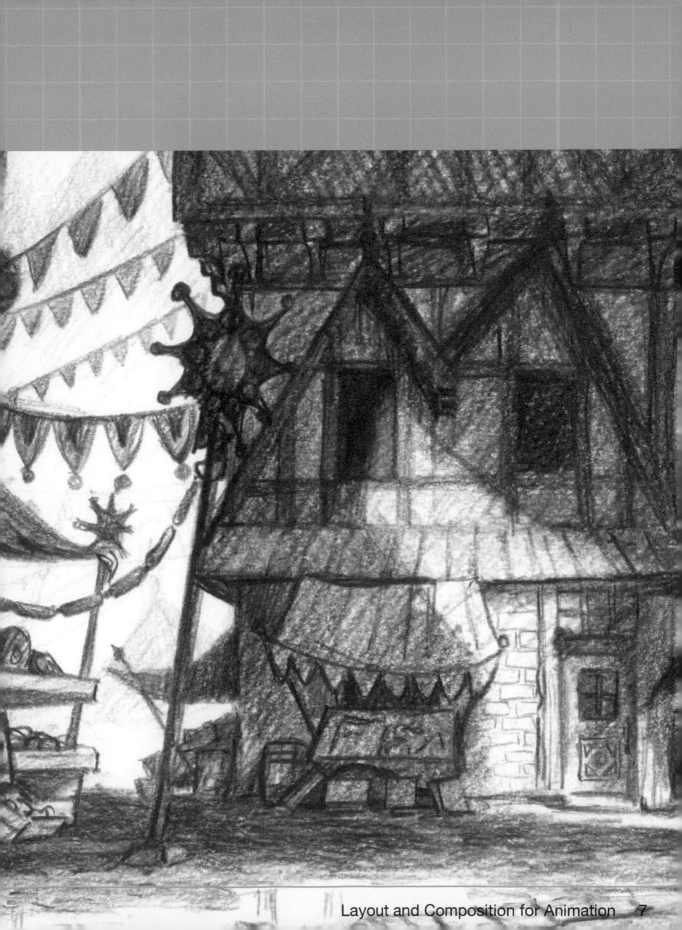

1 Story Tools

© Disney Enterprises, Inc.

© Disney Enterprises, Inc.

- Scene/Sequence
- Script Breakdown
- Workbook
- Thumbnails
- Research

ONCE UPON A TIME

by

Joe Screenplay Writer

1

This chapter gives you some insights about how to manage the thought process behind supporting a story artistically. It discusses how to break down a script into its major action or plot points and then pair those with technical and the storytelling needs in your artwork and show why it's important to research, research, research!

Scene
Sequence

A scene is made up of visuals that tell a specific piece of a story. It is an element, which along with other scenes in an orderly progression become a sequence. Multiple sequences make up the entire picture or show.

In example 1, the script would read, "Bill walks across the street away from camera, stops by a car, reaches into his pocket and suddenly remembers that he left his keys in the restaurant." The following examples show a series of storyboard panels that represent one scene.

Alternatively, the scene could be done with cuts inserted (example 2), which would change the final pace of the final product by making multiple scenes. In animation, these multiple scenes form a sequence, and a series of sequences strung together form a movie.

1

Scene 1 I A

Bill walks across the street away from camera...

Scene 1 I B

...stops by a car, reaches into his pocket and...

Scene 1 I C

...suddenly remembers that he left his keys in the restaurant.

2

Scene 1 | A

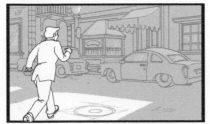

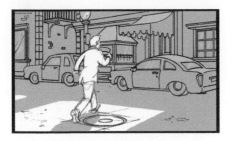

Bill walks across the street away from camera...

Scene 1 | B

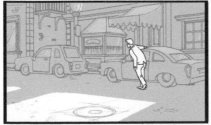

...stops by a car, reaches into his pocket and...

Scene 1 | C

...suddenly remembers that he left his keys in the restaurant.

Script Breakdown

First, read the script! Read the whole thing, not just the scene at hand. While this might seem an obvious step, you'd be surprised how often this is not done. It's important to have a comprehensive view of the entire story so your work remains consistent throughout.

After you've read the script, break it down. Storyboard artists will do this for story and action, but layout will not necessarily follow that breakdown exactly. As a practical matter, if you're working as a freelancer, you'll certainly want to answer these questions about the artwork so you can provide an accurate quote. If you're on staff, you'll need to know this so you can estimate the amount of time art production will take. You'll want to take a view of the entire story so your work remains consistent throughout. I draw quick thumbnails in the margins of the script so I have a rough count of how many and how challenging each layout might be.

ONCE UPON

Joe Scr

EXT. OPEN OCEAN - NIGHT

BRANIEL'S ship sails under a full moon. Ramstead's **EVIL SEAGULLS** follow the ship silently. We **HEAR** the lead gull, **ZOMBIE**, report back to his evil master.

ZOMBIE
(whispers into headset)
Braniel at Latitude 4.565474, Longitude 62.226565. Send the calimari.

Suddenly, out of nowhere, a **GIANT SQUID** emerges and pulls Braniel's ship down under the water.

EXT. PRINCESS SYDNEY'S CASTLE - EARLY MORNING

SYDNEY peers out her tower window. She picks up a spyglass and tries to see as far onto the water as she can. Braniel's ship is nowhere to be found. But she does see some wooden flotsam floating on the surface of the water. It is a name plate for the Sweet Sydney, Braniel's ship.

SYDNEY
My word! Braniel's ship!

goes to her bedroom wall and pulls the alarm switch. Hundreds of escape from myriad holes in the wall. Each of them carries an eir back. They disappear down the long winding staircase and other places in the castle.

SYDNEY
ust find him!

own the staircase.

SYDNEY
MS!!!

tairwell which opens into a great hallway.
tle appears to be totally empty containing
ce.

ER!

iter

100 Dream Street
Hollywood, CA 90028
555-260-8196

Script Breakdown

Scene Number

Helps you keep track of where in the script a particular layout will be located.

Scene Description

What happens and what is the point of the scene? How can your artwork best push forward the beats in the scene?

What character is the lead in the scene?

Placement of the lead character in the composition will either strengthen or weaken the story being told.

Time of Day

Values can affect how busy a scene or composition is. It can also create large clear spaces for characters to work within or against.

Day: Shadows important?
Night: Lighting important?

Movement/Action

Path of action for character

A path of action or clearing for the characters or objects to move will define where and how much detail is put into each background. A path of action can be implemented in a still shot by leaving some "air" around the character. If the field is too tight the character seems trapped and unable to move. Trapping a character this way might send the wrong message about the scene.

Camera move (subjective or objective?)

Ninety-percent of the time camera only moves because a lead character moves off-screen. Because of this, camera should never lead the action unless called for.

For instance, handheld camera moves work as an effect, not a constant! If your character is woozy or confused, you might use this effect, but you wouldn't want to abuse the technique. Use it only to tell a

significant part of the story. Otherwise, it just distracts from the overall action and (to me) becomes an annoying point of view. The camera should never lead the action. Leave that to the characters and their emotional connection to the audience. There are exceptions to this rule and usually occur as establishing shots or when a director wants to show a local. Another instance would be when the camera moves off the characters and up to the sky as a scene cut or dissolve device.

Point of View (POV)

Submissive: Down shot

Anger: Upshot with slight rotation (dutch angle)

Leader: Upshot

Lost/Hiding: Character small in field or fearful large in foreground and crowded to one side or the other.

Psychotic: Tilted or dutch angles

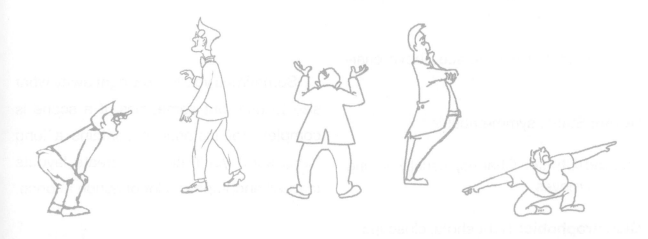

Script Breakdown

continued...

Atmosphere

All have an effect on the visual look, and the physics and physical actions of the characters.

- Rainy
- Cloudy
- Sunny
- Underwater
- Outer Space
- Smoky
- Foggy
- Dusty

Mood

Happy: Long shots with lots of air (space) around the characters

Sad: Downshot with space above characters

Bored: Static, symmetrical

Excited/Chase: Chaotic, usually strong camera moves

Claustrophobic: Tight shots, closeups

Color and Technique Required

Could be...

- Monochromatic/Noir
- Graphic/Flat/Paint by numbers
- Realistic/Fully rendered
- Airbrush/Soft-mixed/Blended
- Backlight, high-contrast color

Timing

Ask:

- How long is the scene?
- Is the action: Fast, slow, sporadic?
- Do you have to match speed or position of a previous scene?

Size of Layout

Sometimes you'll know right away what size to use, but sometimes, if a scene is complex (for instance it contains a long travel shot) you'll need to create layouts that will encompass a lot of action at once.

Object Specifics

Ask:

- What set pieces are relevant and necessary to the action described in the script?
- Which are layout objects?
- Which are held objects to be drawn by animators rather than by a layout artist?

The workbook process is part of how layout artists support the cinematic portion of the animation process. While an expert storyboard artist usually knows perspective and camera, not every storyboard artist does, and often they tend to concentrate mostly on acting in the scene. When this is true, the Layout Artist can be asked to create a workbook based on the storyboard. A workbook consists of compose shots and usually shows camera moves and positions so each scene can be properly envisioned by animators and layout artists alike.

A workbook solidifies all the latest information (animation direction, character design, layout) into one drawing. The Art Director is then able to use the workbook and design the lighting direction and rough out color comps in a thumbnail process. Workbook is used in both computer graphics and traditional animation.

© Disney Enterprises, Inc.

© Disney Enterprises, Inc.

© Disney Enterprises, Inc.

Key Location Designs from "The Great Mouse Detective"

Workbook

In many of the workbooks I've created I'll place the design in the workbook so there is no confusion about what the sets look like. The layout artist will read the script and make notes as to the character of the set to be designed. The creative story telling will be done here. Will the house be a haunted Victorian? A ranch style? A brownstone?

One of the best things about being a layout artist is the opportunity to add to the story with your work. Always feel free to draw examples of your ideas and show them to your co-artists, animators, directors, and supervisors. It's always appreciated and you'd be amazed how many good ideas get added into a picture by doing this.

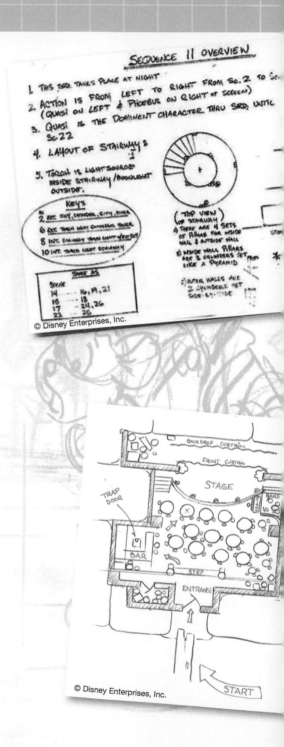

© Disney Enterprises, Inc.

© Disney Enterprises, Inc.

© Disney Enterprises, Inc.

Layout and Composition for Animation 23

Thumbnails

I'm All Thumbs

Some artists get lost in detail without a strong shape to hang the details on. The most important guideline in Layout is to always start with a thumbnail or small quick sketch mainly focusing on shapes and not detail. This allows the layout artist to see the story as a whole first and will help with overall continuity as work on the picture

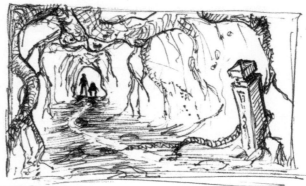

© Disney Enterprises, Inc.

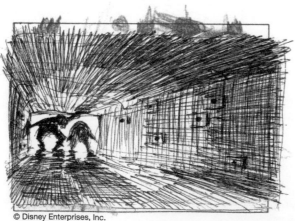

© Disney Enterprises, Inc.

© Disney Enterprises, Inc.

progresses. If an artist becomes too in-vested in particular details of design at the very first, it becomes difficult to make the changes that will inevitably be required. It's better to remain fluid and not get bogged down.

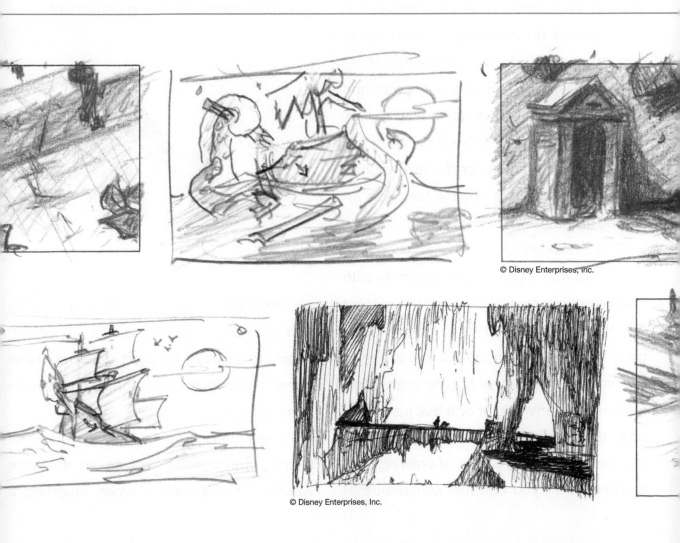

© Disney Enterprises, Inc.

© Disney Enterprises, Inc.

Thumbnails

Make a list, check it twice...

To avoid getting lost in detail, a suggestion I give when I'm lecturing is to create a list of style examples or words that will trigger your attention to look twice or more at the foundation of your design. Pin the checklist up near your workspace so you can see it. In my experience there are times when I'll be working away and will suddenly feel my creative flow fading. When that happens, I'll check my list to see if I just need a break, or if I've designed myself away from the original concepts included in the list and am just kind of lost.

The checklist should be of your own making to make you feel comfortable with critiquing your own work, rather than a list that has come from a higher authority. Nobody likes to be critiqued but that is part of the process. Instead of turning in an incorrect piece of artwork, or one that just might have a few mistakes, make a list. Use a few seconds in every hour of drawing time to check it so you can feel confident that you did your best to meet the design criteria for the scene. This really does cut down on the number of times a director or art director rejects your work and will help win you a reputation for being consistent.

Detailing/Drawing Through

Once the initial thumbnails are done and you begin designing, it's important, again, to not get bogged down in detail without strong shapes supporting everything beneath.

When designing a layout, think of shapes and volume just as an animator would. For instance, when roughing a

tree, draw through the shape; show the direction of the turn of the tree with your line work. Show the curvature of the earth.

It works the same as drawing a character. First, the basic shape is drawn, and then clothing and hair are added. It would just be weird to start with hair and clothing first, right? It would be nearly impossible to draw the character on model that way. The same principles exist in layout. Draw the basic shapes and then add foliage, buildings, roads, etc.

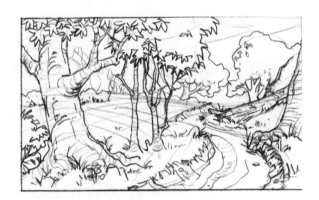

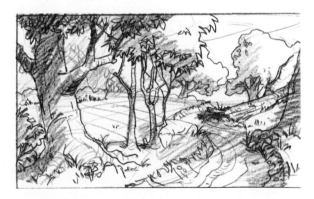

Research

Sometimes, layout artists work with other artists and directors in development.

Or, perhaps you'll create your own project or work as a production designer or art director. In these cases, you'll need to participate in the creation of the story, including ideas about story, style, and where the production will be completed.

Research

The Lake

Let's suppose that all that is known is that a story involves two children at a lake. No one has imagined the specific location of the lake, only just that it needs to be a lake.

In a case like this, like cinematographers for live action productions, layout artists research locations so they have various examples on hand for consideration.

This kind of research can be very helpful to a story that hasn't quite gelled yet. It can spur new ideas from other team members and move the development of a project forward because the story and characters, at their roots, are all based in where the story takes place.

It's a very satisfying way to use one's layout skills.

Maybe the lake is a mid-western lake with birch trees lining the shore and cat-tails in the water near the shore. It could have a little pier and houses peeking out from behind the trees, or;

it could be a swampy lake surrounded by moss-covered cypress trees. Some trees might be fallen down and maybe we see a small, broken-down cabin near the shore, or;

perhaps it is a glacial lake high in the snow covered mountains with very little foliage surrounding it and only a tiny little rock island in the middle where one scraggly tree and a bit of grass are holding on for dear life in the cold.

Research

Story

and art direction has generally already been determined before a layout artist is assigned to a production. When this is the case there are fewer conceptual thought processes to participate in. Generally you'll fit your artwork to other's concepts.

Nevertheless, you will need to research locations and understand things specific to those kinds of places so you can accurately portray the world on film. Back-story and details help the audience accept your caricature of a world, even if the world you're creating is a fantasy.

Research is a breeze these days with access to so much media: books, pictures, movies, and especially information from the Internet.

There's no excuse for not doing research!

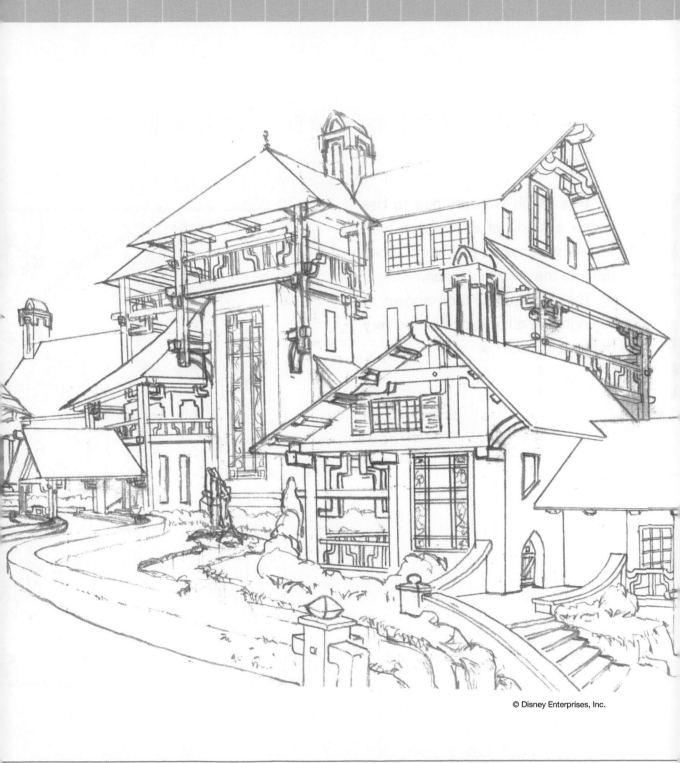

© Disney Enterprises, Inc.

Research

ATLANTIS: Whitmore's Study with Aquarium Window

This rough was an idea to describe a study of a very rich man whose window to the world looks out into the Atlantic Ocean.

The research photos shown at top right are all reflected in this very detailed layout.

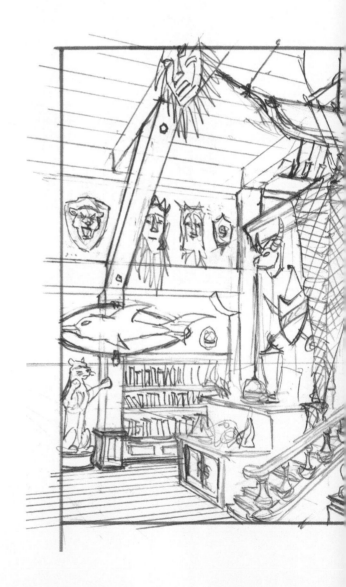

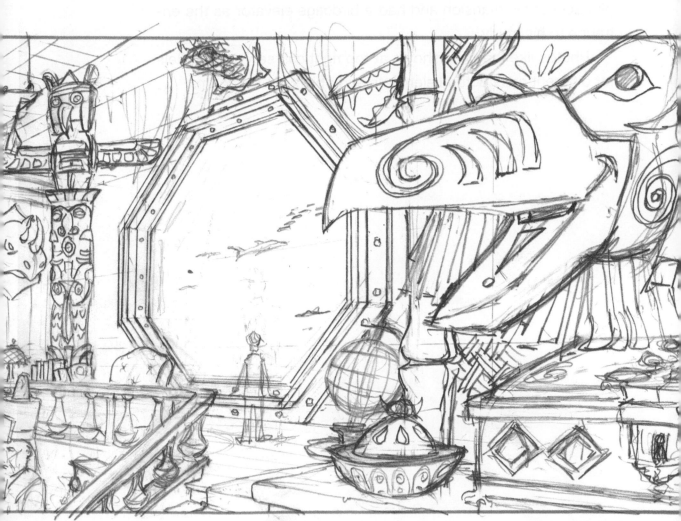

ATLANTIS: Whitmore's Study with Aquarium Window

These roughs represent that Mr. Whitmore's study was at the pinnacle of his mansion and had a birdcage elevator as the entrance to his study.

Photos like the ones shown at top right can serve as models for different architectural elements and objects in the room.

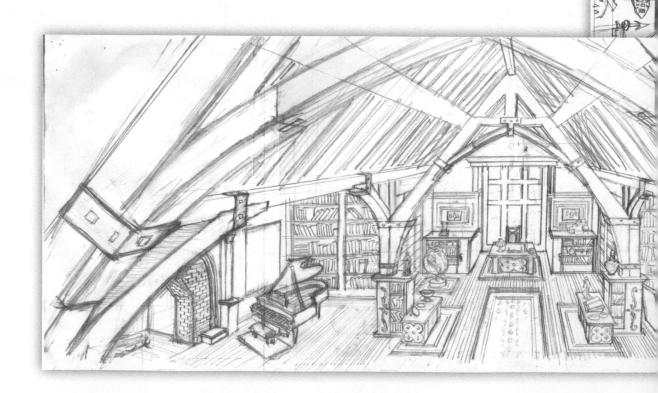

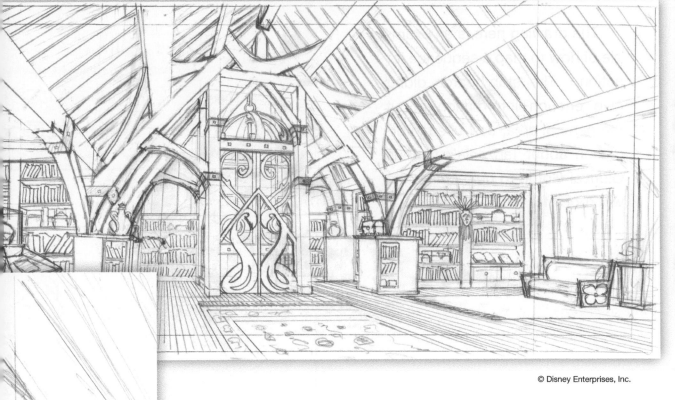

© Disney Enterprises, Inc.

These designs show the whole study from two angles. When one looks at the drawings, information about the entire environment can be viewed.

© Disney Enterprises, Inc.

esearch

THE LION KING : Sequence Mapping & Hyena's Hideout

The drawing here is an example of how to map a sequence for action. The storyboards didn't give enough information about the general area, so I used information about Tanzania's famous Olduvai Gorge to help create the workbook for the scene.

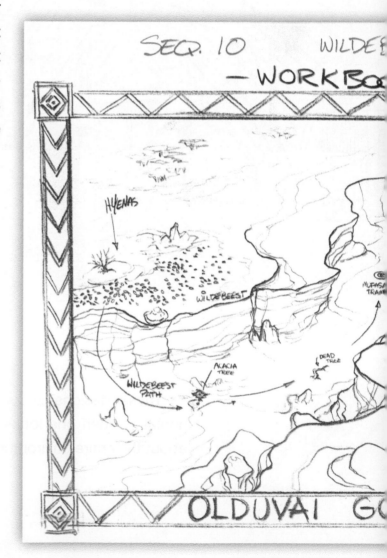

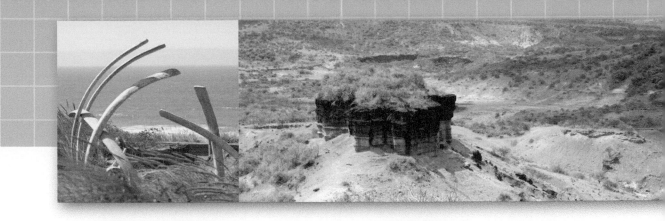

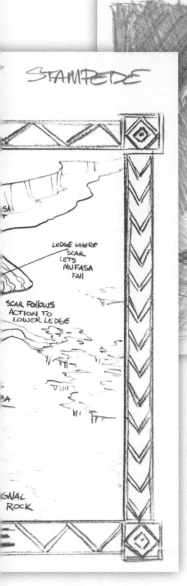

STAMPEDE

LEDGE WHERE
SCAR
LETS
MUFASA
FALL

SCAR FOLLOWS
ACTION TO
LOWER LEDGE

GNAL
ROCK

In the reference photo shown at the top, whale-bones poking up from the sand inspire a concept for the hyena's hideout at the elephant's graveyard.

THE HUNCHBACK OF NOTREDAME : Clean-up Layout & Nightime Renderin

This clean-up layout of a street in Paris shows many details; however, it could be any time of day. The reference photos shown at the right exhibit the architectural and textural details needed to create an authentic layout of 1800s Paris.

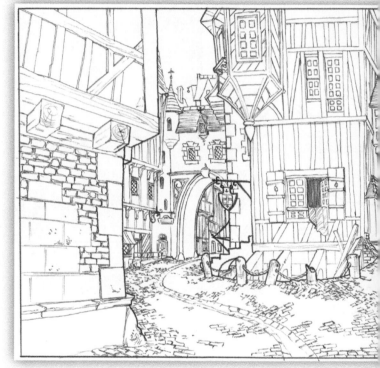

© Disney Enterprises, Inc.

The rendering here shows that it is night time. Notice the two twilight shots in the reference material above. The difference between night and day in the reference shots is that the sky is a lighter value than at the tops of the buildings which silhouettes them. As values are applied to the rendering vertically, details become more accentuated toward the bottom. Daylight is the opposite of this. Stronger silhouettes appear at the bottom of the building rather than at the top.

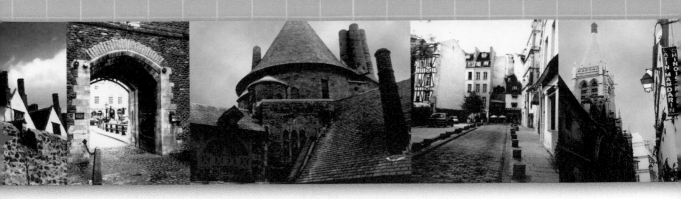

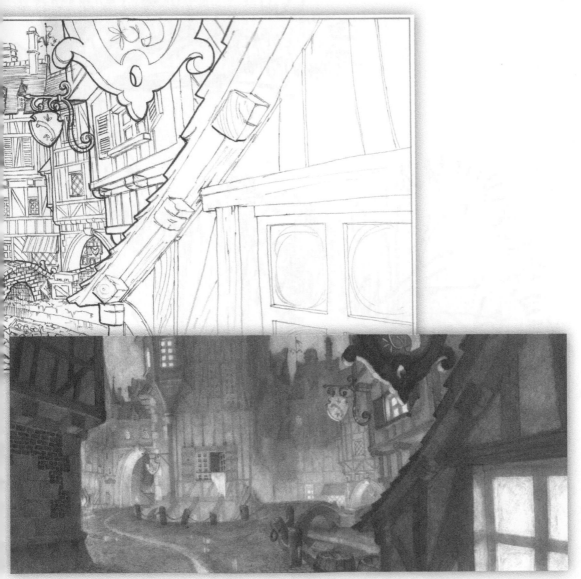

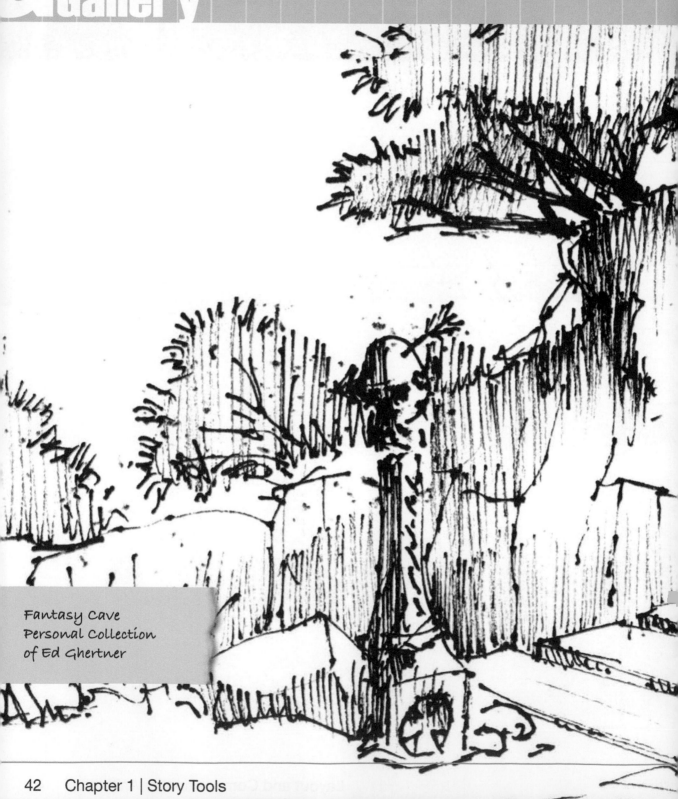

Fantasy Cave
Personal Collection
of Ed Ghertner

2 Perspectives

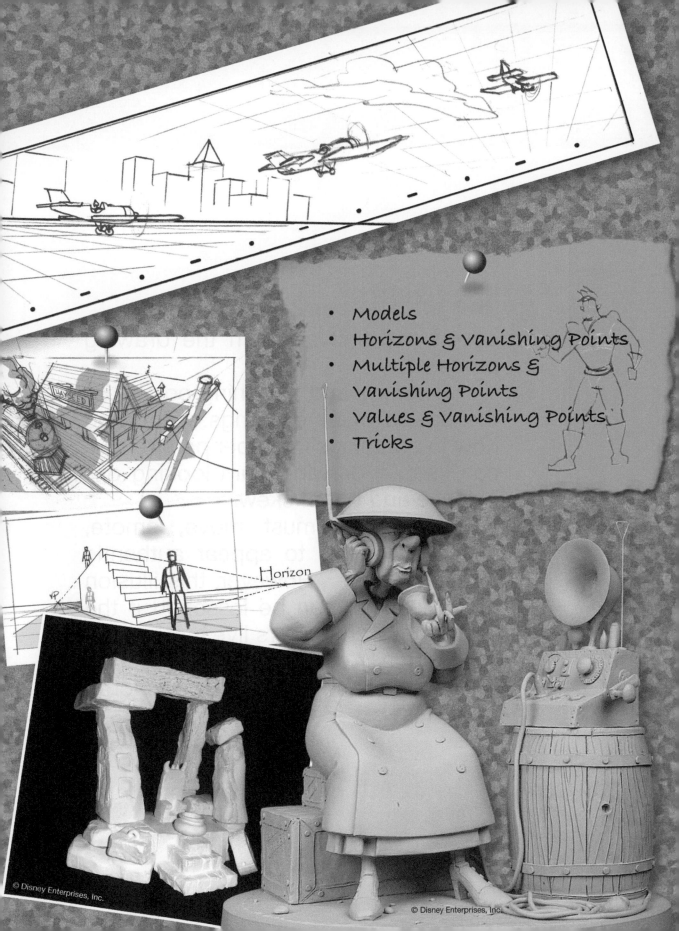

- Models
- Horizons & Vanishing Points
- Multiple Horizons & Vanishing Points
- Values & Vanishing Points
- Tricks

Horizon

This chapter...

covers the first steps in the drawing process.

Horizons and vanishing points are the basics of all drawings. Knowing how to put things in proper perspective can keep a drawing from looking off-balance and out of skew.

Characters must move, emote, and be dynamic to appear authentic to an audience. However, this illusion of authenticity can be lessened if the world these characters live in does not seem equally dynamic and if the characters do not seem properly anchored within it.

This chapter also discusses how to use multiple horizons and vanishing points to create a more dynamic composition and a more interesting story.

Models

After finding the horizons and vanishing points in a composition, one can place characters and objects into the drawing in a way that "seats" them properly in that space.

Placement of objects within the composition can affect scale. The common approach is to place the characters in the composition so that they match a realistic size to the other objects within, but you might like to caricature the scale of the characters larger or smaller to give a cartoon or comic feel.

Three-dimensional models can help an artist to better understand the shapes of

Character Maquettes for Disney's ATLANTIS

© Disney Enterprises, Inc.

© Disney Enterprises, Inc.
© Disney Enterprises, Inc.

things since this model can be seen from all angles. Similarly, character artists are provided with character sculptures, or "maquettes".

Computer animation allows for simple models of background and objects to be built in virtual space, and artists can now use these as a guide for perspective shots.

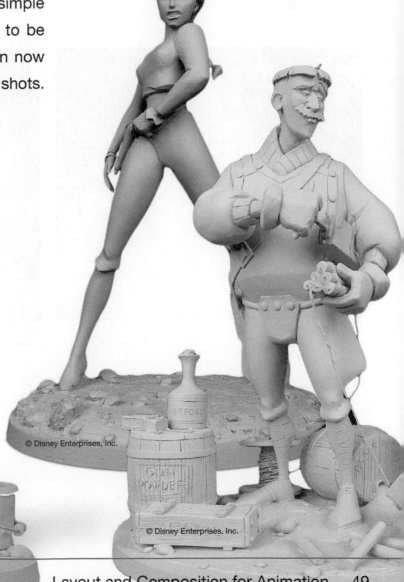

Models

Traditional Layout Models

Here are photographs of three-dimensional layout models for some of the 2-D projects I've worked on.

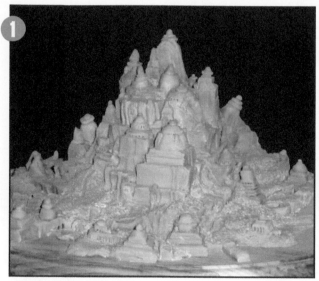

© Disney Enterprises, Inc.

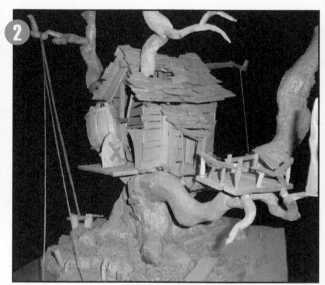

© Disney Enterprises, Inc. Based on the "Winnie the Pooh" works, by A.A. Milne and E.H. Shepard.

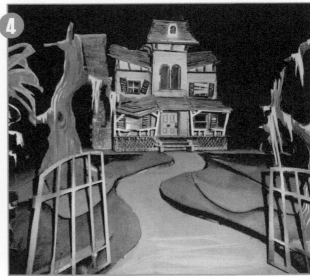

1 Disney's "Atlantis" (Feature)

2 Tigger's House
(from Disney's "The Many Adventures of Winnie the Pooh" TV Series)

3 Disney's "Black Cauldron" (Feature)

4 Halloween Project (personal)

odels

CGI Layout Models

The modeling process is similar in computer graphics. A concept design is created, and elevations are drawn — top, sides, front and back — of any objects to be built in the computer. Here is an example of the computer model design process.

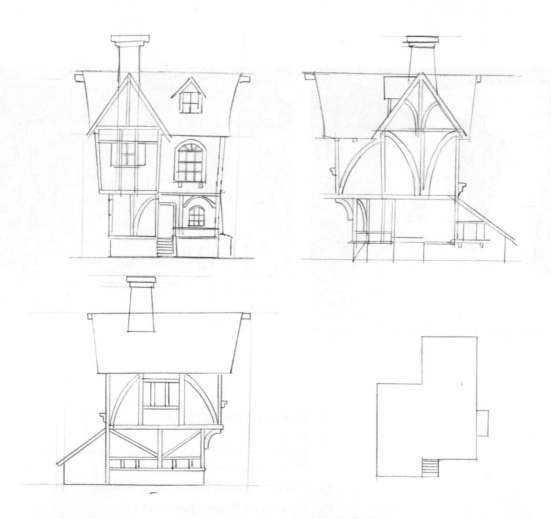

Linear elevation drawings

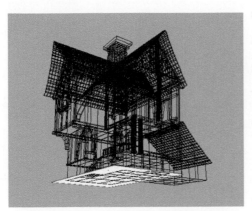
Wireframe based on linear drawings

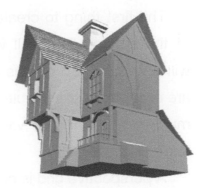
Smooth-shaded over wireframe

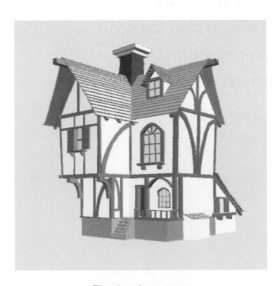
Final color comp

Horizons & Vanishing Points

Using a Perspective Grid

The first thing to create is the position of the horizon line. All vanishing points will be positioned on this horizon. (There are exceptions to this rule, and we'll cover multiple horizons and vanishing points in another chapter.)

A perspective grid is necessary for this. Grids can be purchased at an art supply store to be used underneath your drawing on a light board, or if you're working on the computer, you can scan one in and place it over your drawing as a layer. While working in Photoshop, I always start my compositions this way, turning the grid layer on and off as I work through the design.

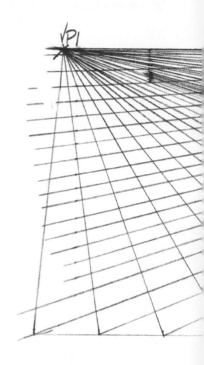

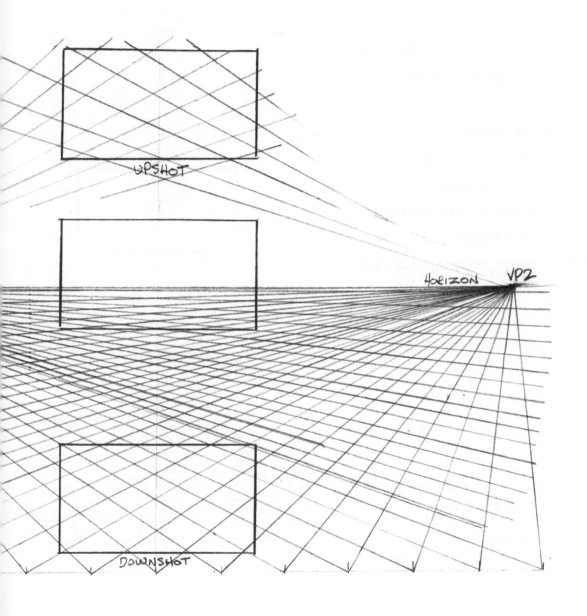

UPSHOT

HORIZON VP2

DOWNSHOT

Perspective Grid Related to Horizon & Vanishing Points

Here are three examples of the position of the horizon and vanishing points most often used.

The vanishing points create the grid that represents the ground plane (which I'll speak to later in this chapter).

In the common eye level, the horizon is in the middle of the screen. The center of the picture plane (or field) floats just above the horizon line.

In a down shot, the horizon is either at the top, or as shown here, actually off the picture plane.

In an up shot, the center of the picture plane is above the horizon.

1. Picture plane with a rough position of the horizon.

2. Rough horizon with vanishing points that create perspective grid.

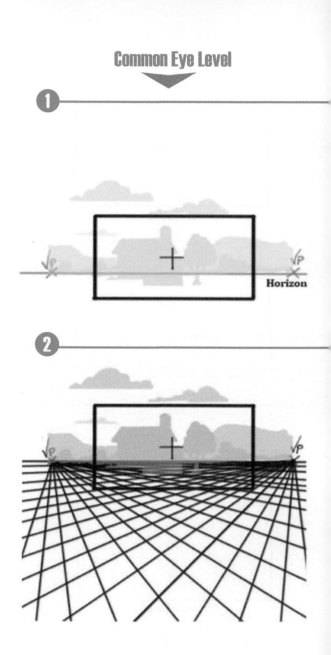

Common Eye Level

Down Shot

Up Shot

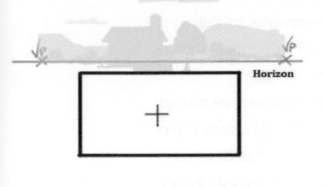
Horizon

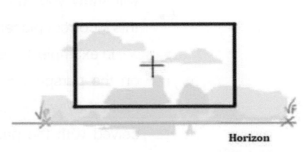
Horizon

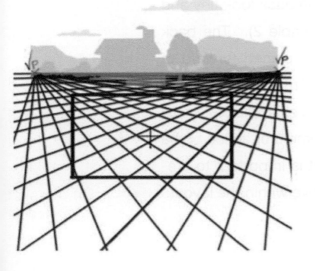

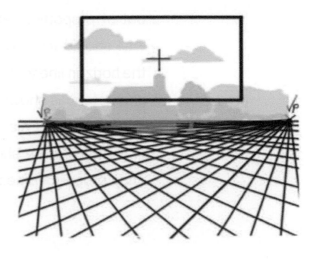

Horizons & Vanishing Points

Interior Limitations

Within an interior, a common mistake is to place objects on the horizon rather than at the correct placement within the perspective grid. The examples to the right will show you what could happen should this incorrect placement occur.

In example 1, the characters are placed on the perspective grid. However, if the room they will be placed in has been conceived with the back wall placed directly on the horizon, the room looks huge, making the character at the back look tiny and out of proportion (example 2). The back wall should instead be placed forward of the horizon line to the size proportion of the characters as shown in example 3.

Knowing the placement or action of the characters in the shot is important to creating proper perspective within the layout.

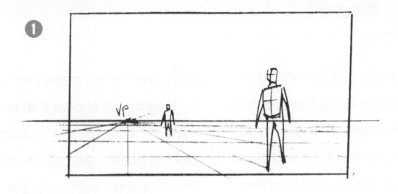

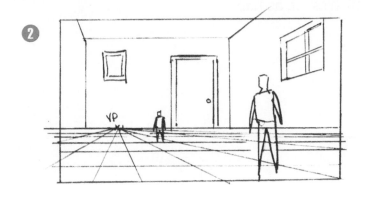

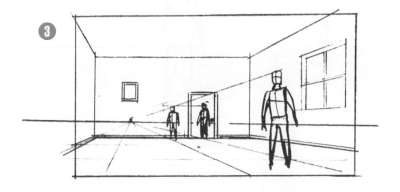

Horizons & Vanishing Points

Object and Character Placement on Uneven Ground Planes

As shown in example 1, if the horizon is waist high on a character in the foreground, it will be waist high wherever the character is placed or moves within the picture plane. The exception is if the ground plane raises or lowers, or the character walks up or down stairs (example 3), hills, or, as happens often in animated film, they fly.

Example 2 shows that a character might have to walk or be placed on a curved ground plane. As before, find the height of the character vertically placing him or her on the curved plane.

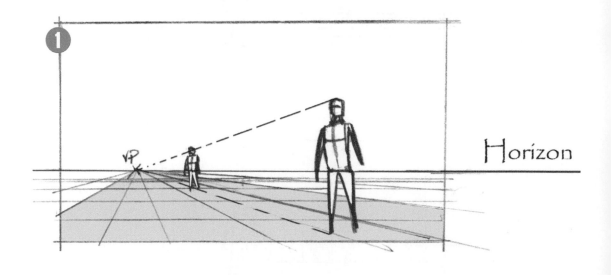

Horizon

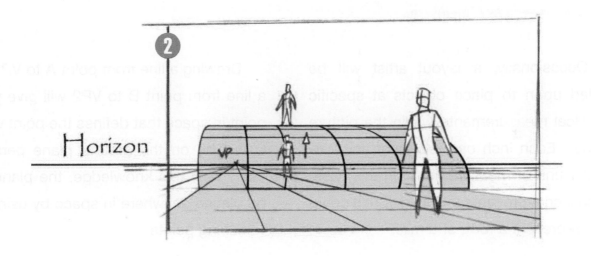

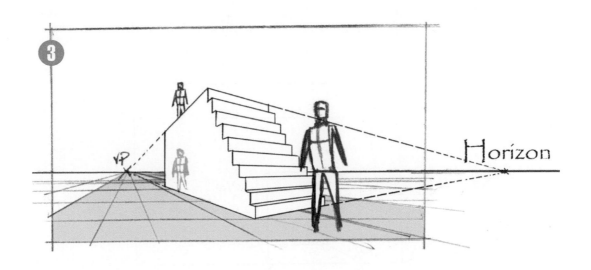

Horizons & Vanishing Points

Creating Objects with Exacting Measurements in Perspective

Occasionally, a layout artist will be called upon to place objects at specific physical measurements within the picture plane. Each inch can represent any particular unit of measurement. In this case, each inch represents one inch. But it could also represent a foot, or a mile.

Drawing a line from point A to VP1 and a line from point B to VP2 will give you point in space that defines the point when C will be on the ground plane perspetive. With this knowledge, the plane can be placed anywhere in space by using the vanishing points.

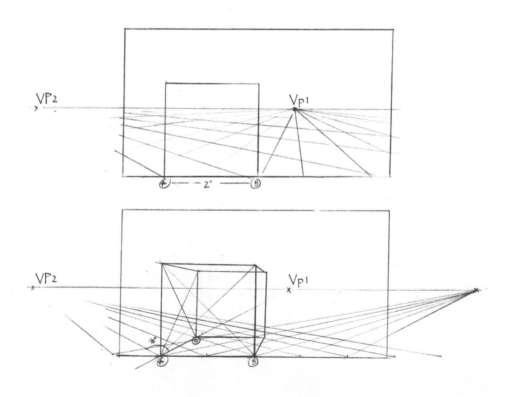

For example, if it is known that the two lines drawn 8-inches left and right of center are connected to VP2 and VP3, they will intersect 8-inches into the picture from the picture plane.

VP4

VP2

VP1 45°

VP3

VP5

Multiple Horizons & Vanishing Points

A Horizon on the Horizon

There are situations when composing for film, where a character's position in the composition works at one position, but not in another within the same field. The easy way out would be to add a camera move, but there are times when you don't want to move the camera, or you can't.

The solution is to find where your character fits in the fielding, then work from that position out. In this example of a narrow hallway that leads to a doorway (frame 1), the character will travel from the foreground down the hallway, and through the door. To get the perspective right, I start by positioning the character in the doorway (frame 2) since I know how tall he is in comparison. This composition is a one-point perspective shot, so I've chosen a vanishing point on the horizon line shown in blue. I

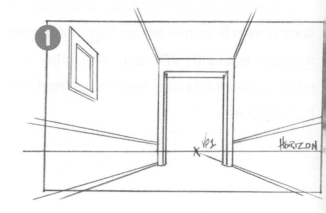

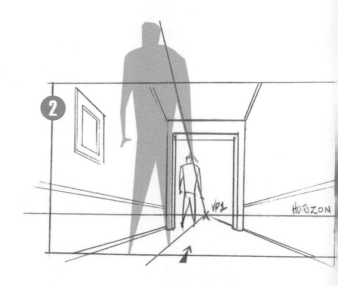

drew a line from the vanishing point on the horizon, through the top of the character's head and out past the picture plane.

Next, draw a line from the same vanishing point on the horizon out through the feet of the character and out past the picture plane. Now you have the perspective plane your character will travel on, into the field, or out.

As you can see, the character starts off screen (frame 3). In computer graph-

ics and live-action, you can change this by changing the lens ratio, but in a drawing you'll have to "cheat" the perspective to simulate a lens change.

The solution is to add another horizon and vanishing point. To start, let's use the character in the doorway with the horizon and vanishing point from frame 2. Once again, draw a line from the vanishing point through the feet of the character in the doorway and out past the picture plane.

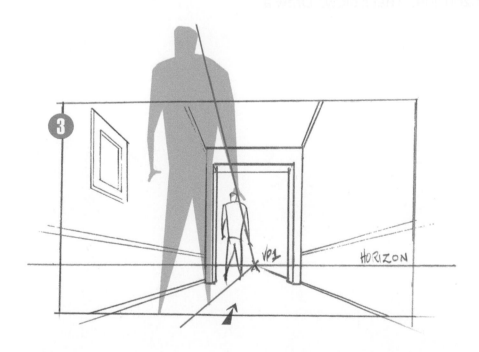

Now draw the character in the foreground so that he fits in the picture plane with his feet on the line just drawn (frame 4). With both characters in their most extreme positions within the frame, draw a line from VP 1 through the head of the character in the doorway. Continue that line through the head of the character in the place it will stand in the foreground, and then out through the picture plane (the lines drawn here in blue). You will notice that it doesn't cross the horizon line. That's okay. Draw a vertical line from the vanishing point on the horizon until it crosses the line just drawn through the heads of the character. The point where the lines meet will give you the position for the second horizon line and vanishing point. The "cheat" is that any vanishing lines on the background will be in between, or split between the two horizons and vanishing points. The chair rails and picture on the wall are examples of "the cheat" (depicted by the red lines).

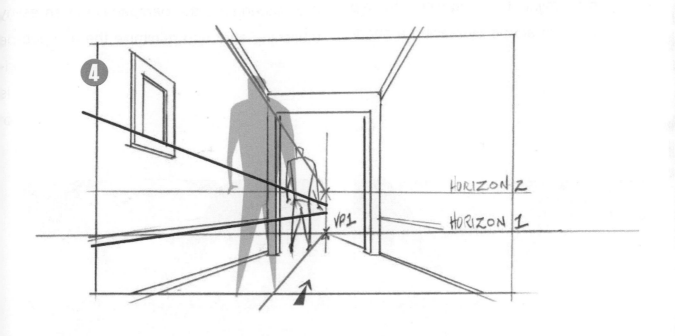

Multiple Horizons & Vanishing Points

When designing a layout, always check to make sure the characters can be clear and visible to the audience. A object in the background should not have a similar shape and size to the character. If it's necessary to a similar shape, lighting can help by splitting that shape by placing a shad-ow across it. A situation that might come up is having a background with a strong one-point perspective in the set-up. It can be very difficult for some animators to act as well as animate in perspective. To help this, accentuate the perspective in an establishing shot and minimize the perspec-

tive in the acting closer shot. If it's necessary to have a strong perspective in the scene with the animation moving on the perspective angle, an overlay intelligently placed over the animation can help hide a miscue in the perspective of the animation.

If a strong perspective is needed, have the animation cross the perspective line; you'll have the depth of the background but the animation can be almost parallel to the picture plane allowing the animator to focus more on the acting.

Multiple Horizons & Vanishing Points

Feet on the Ground

You can get away with almost any perspective on a character as long as the contact points (usually the feet) work with the same horizon as the background.

Close-ups have other clues to solidify the characters and background. Since we use the same horizon for both, in a close-up, the eyes and shoulder planes describe where the horizon sits.

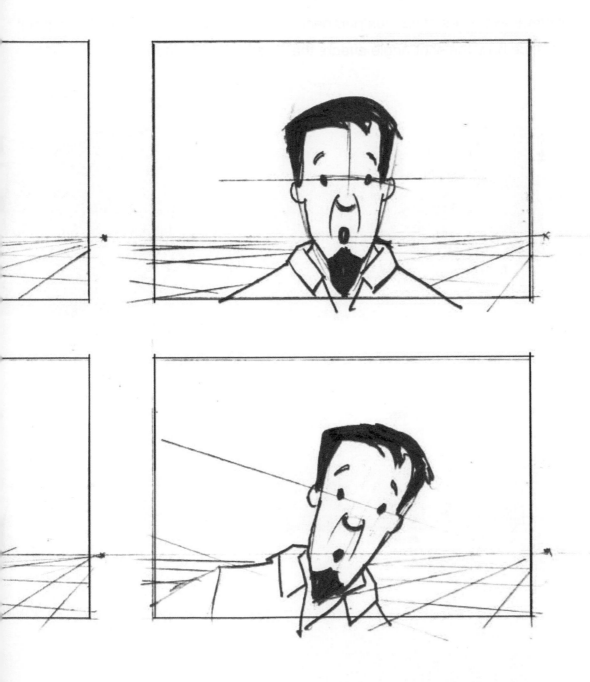

Multiple Horizons & Vanishing Points

What's Your Point?

Here are several examples of various perspectives as compared to a typical one-point perspective. Notice how the shot angle affects the perspective in each.

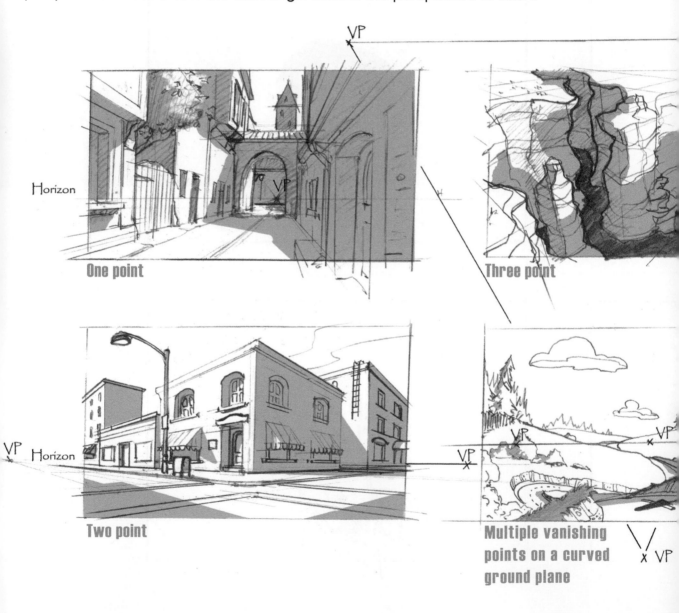

One point

Three point

Two point

Multiple vanishing points on a curved ground plane

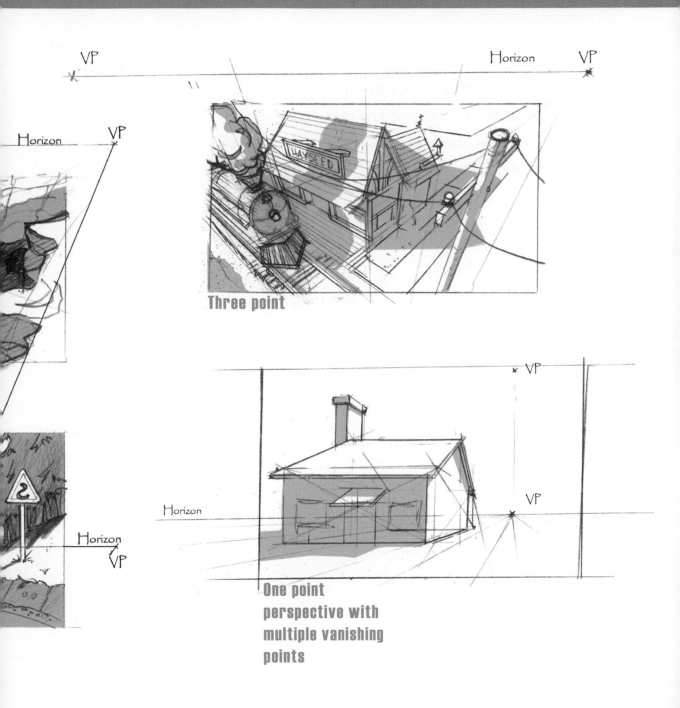

VP

Horizon VP

Horizon VP

Three point

One point
perspective with
multiple vanishing
points

Horizon VP

Horizon VP

VP

VP

Multiple Horizons & Vanishing Points

Inclining/Reclining Planes

Use multiple vanishing points to find the correct perspective for inclining and re-clining planes such as stairs, hills, ramps, leaning, boards, etc.

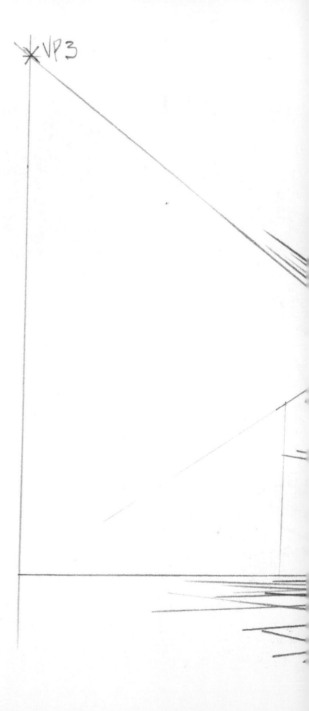

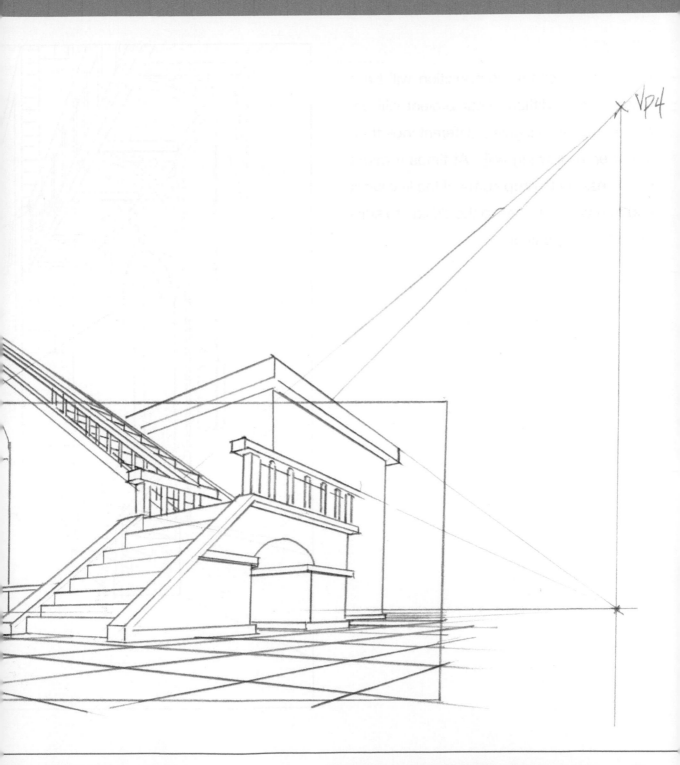

Values &
Vanishing Points

Value Added

The style of the composition will be a factor in how difficult your project will be. A line drawing will give a different look than a rendered drawing will. At times it might be necessary to drop some of the line work and add value shapes to the design to support the composition.

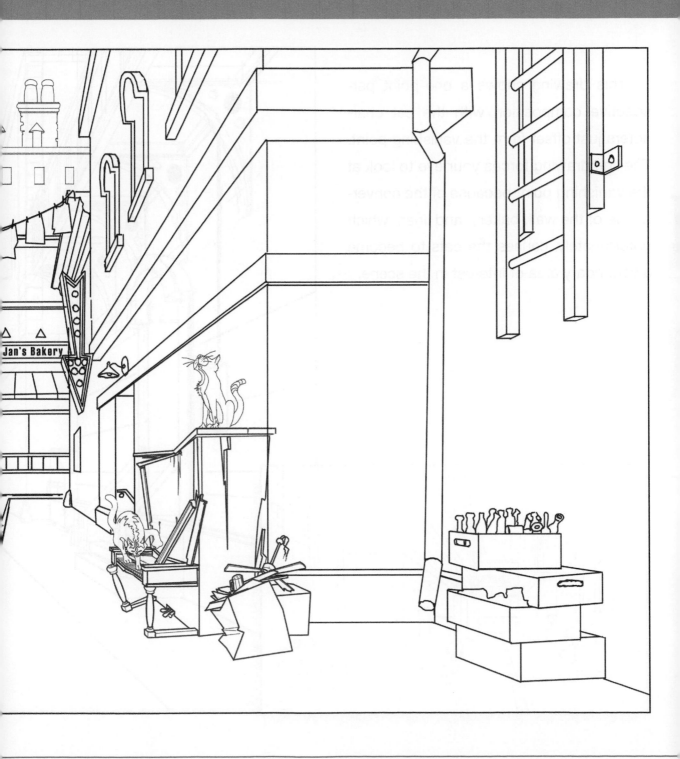

Values &
Vanishing Points

This drawing shows a one-point perspective composition with the cat characters just offset from the vanishing point. The line drawing forces your eye to look at the vanishing point because of the convergence of the wall, bakery, and lines, which unfortunately, causes the cats to become a secondary area of interest in the scene.

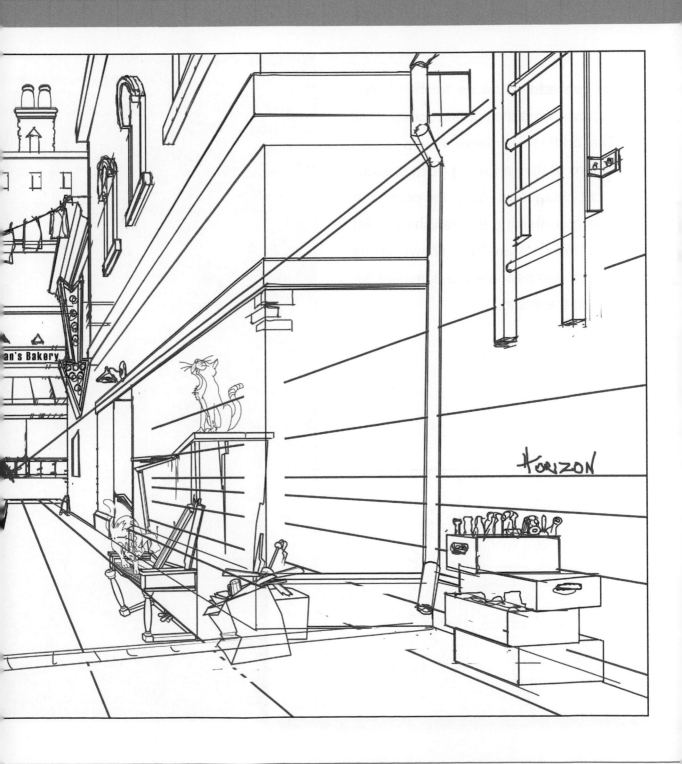

Inside the image: "an's Bakery", "HORIZON"

Values &
Vanishing Points

Here I've added values to the design (which shows what the lighting scheme will be). The addition of these values solves the problem of the vanishing point upstaging the cat characters. With the portion of the drawing containing the vanishing point darkened, the cats are now shown in the lightest area and become the dominant focal point on the stage.

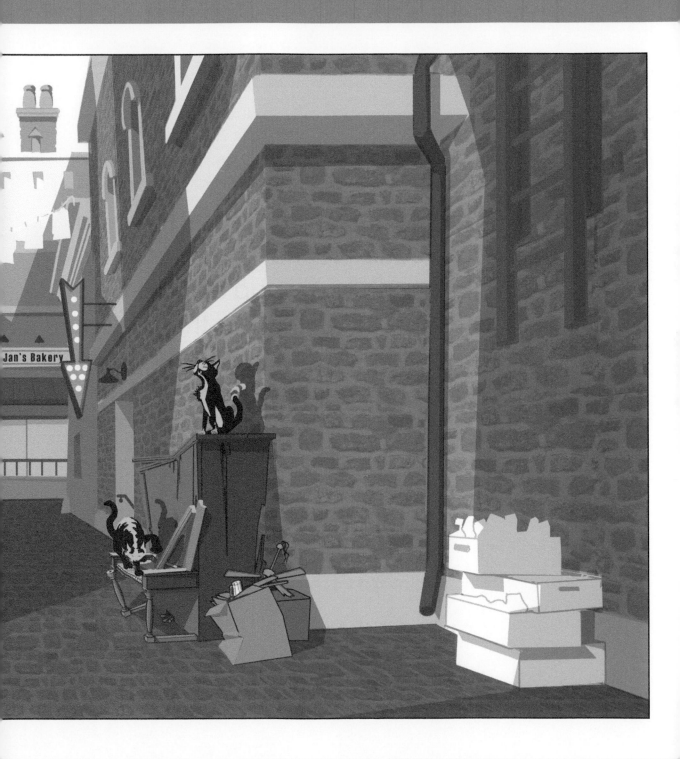

What would you do if your story described a camera move that followed a character around a room running in circles or looking up at a tree as a leaf falls from the top as the camera follows it to the ground? How would you set up your perspective?

Curved Pans

There will be times when it's necessary to have a curved pan background moving from a one-point perspective to another one-point. The trick of this shot is to separate the vanishing points so it's a gradual curve of the perspective, and that you don't have the two perspectives in one field of view at the same time.

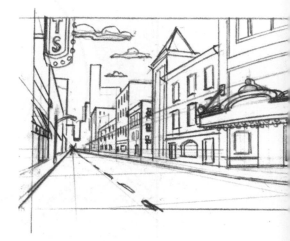

If you follow a character or object in the scene, the animation can be used as a distraction to hide the perspective change if it moves toward the camera filling the field or close to it, and then moves away from camera into the background.

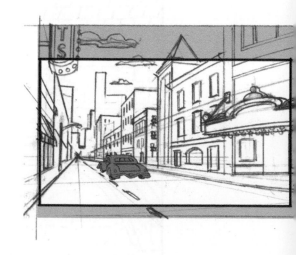

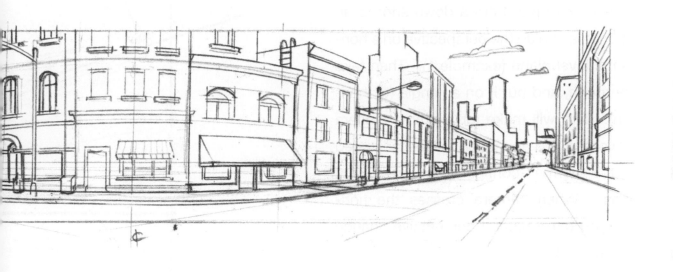

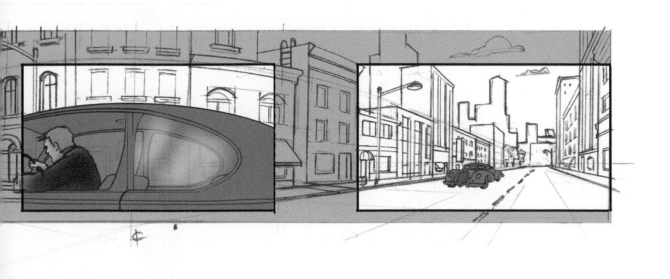

Tricks

A New Angle

A trick to pan from a down shot to an up shot is to plan the perspective on a horizontal level plane (example 1). Then take the rough, and put it on an angle (tilt horizon). This will make for a simple camera move and the animation will be animated in the normal configuration on bottom pegs. When camera crosses the horizon you get a natural perspective change (example 2).

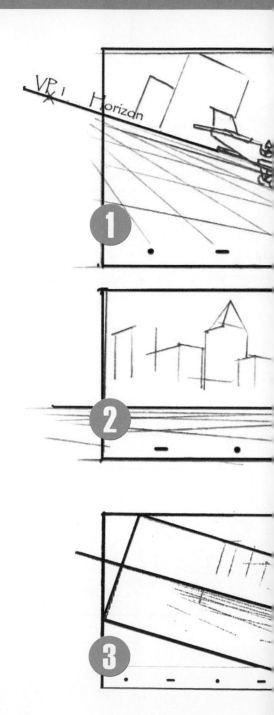

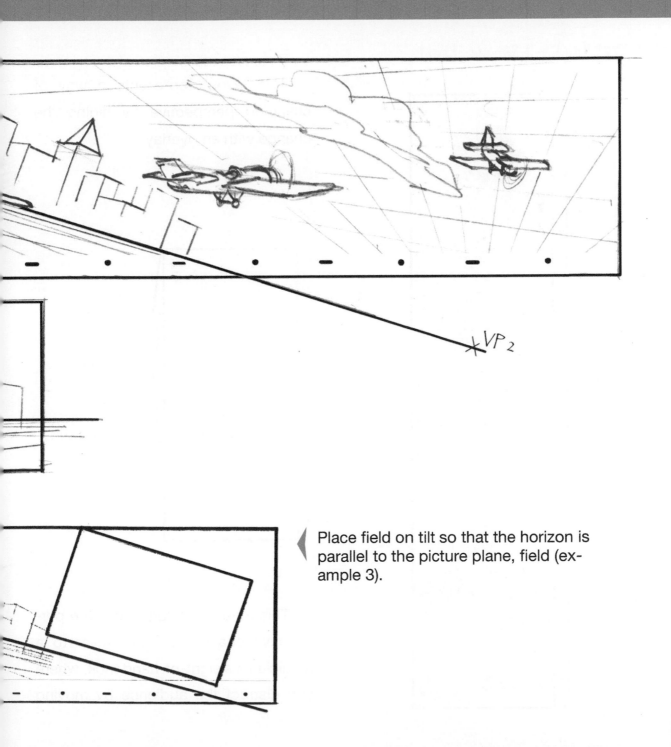

Place field on tilt so that the horizon is parallel to the picture plane, field (example 3).

Tricks

If at First You Don't Suceed...Cheat

BG 1

OL

BG 2

This layout represents a way of changing perspective by hiding the change with an overlay.

Tree OL

Top Plane

Side Plane

Bottom Plane

This method of "cheating" the perspective change is very similar to a magician's sleight-of-hand trick, where you distract the audience by moving

Horizon

something in front of them to get their attention while you're hiding the card or coin in your pocket. In animation by changing the background you accomplish the same thing. Using two separate backgrounds that are changed one for the other while the overlay fills the screen will give you the illusion of a perspective change.

With these tricks it's very important to know the timing of the scene. You'll have to adjust the artwork to match the speed of the scene.

There's always been controversy with the term "cheat." Some use the term to discount their lack of knowledge, and others use the term to correct perspective elements that are drawn in correct perspective but might not look right or pleasing to the eye.

Tricks

When working in animation it's easy to change perspective on objects that move, but it's much more likely that a perspective mistake or oddity will be seen on backgrounds and still objects, simply because they are on the screen throughout the entire scene.

A "cheat" doesn't mean you disregard all basics and put whatever you want in a scene in any position. The horizon will always be an anchor point, but there can be multiple vanishing points and horizons depending on how complicated you make the composition. A "cheat" gone wrong is when two vanishing points are too close to one another on the horizon, which will warp the lines closest to the picture plane or, as said

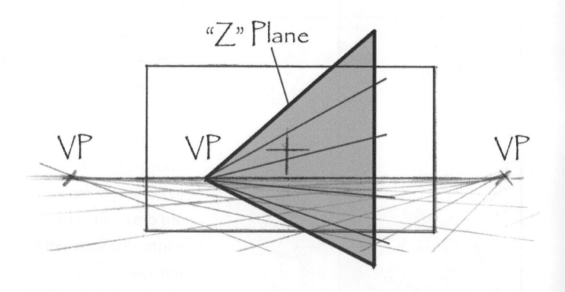

"Z" Plane

VP VP VP

before, placing objects on the horizon. These usually appear in the "Z" plane as it is known in 3-D terms. The "Z" plane starts at the picture plane and vanishes at the horizon. Lines on the "Z" plane are perpendicular to the horizon.

In the 2-D world you can "cheat" the size of objects to create a sense of foreshortening or making objects appear larger than they really should be to accentuate scale. In live-action and 3-D animation you can use different lenses or focal lengths to accomplish the same thing. When pushing the scale in 2-D animation you will have to give the animator an accurate grid combining the two scale changes.

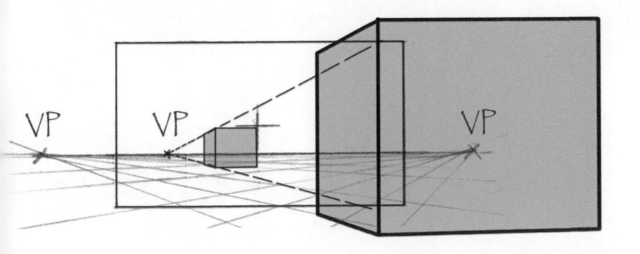

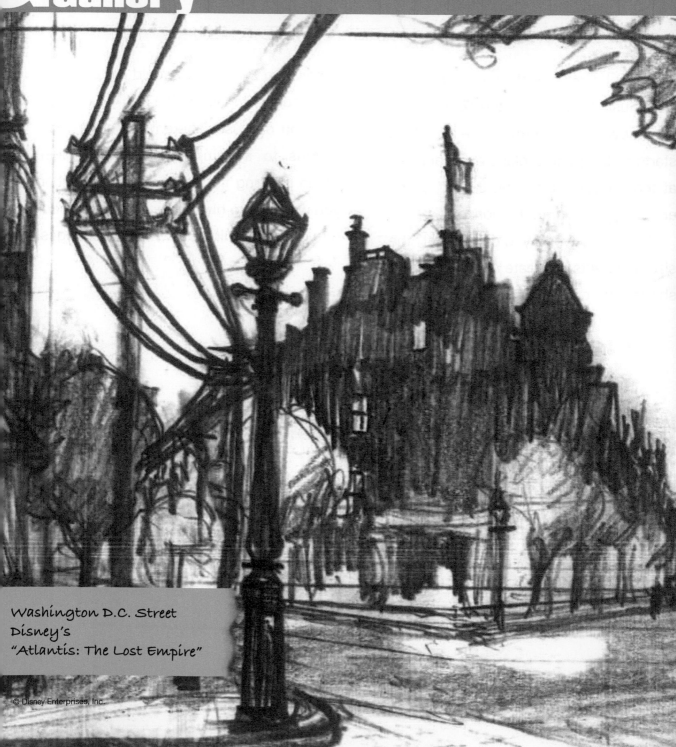

Washington D.C. Street
Disney's
"Atlantis: The Lost Empire"

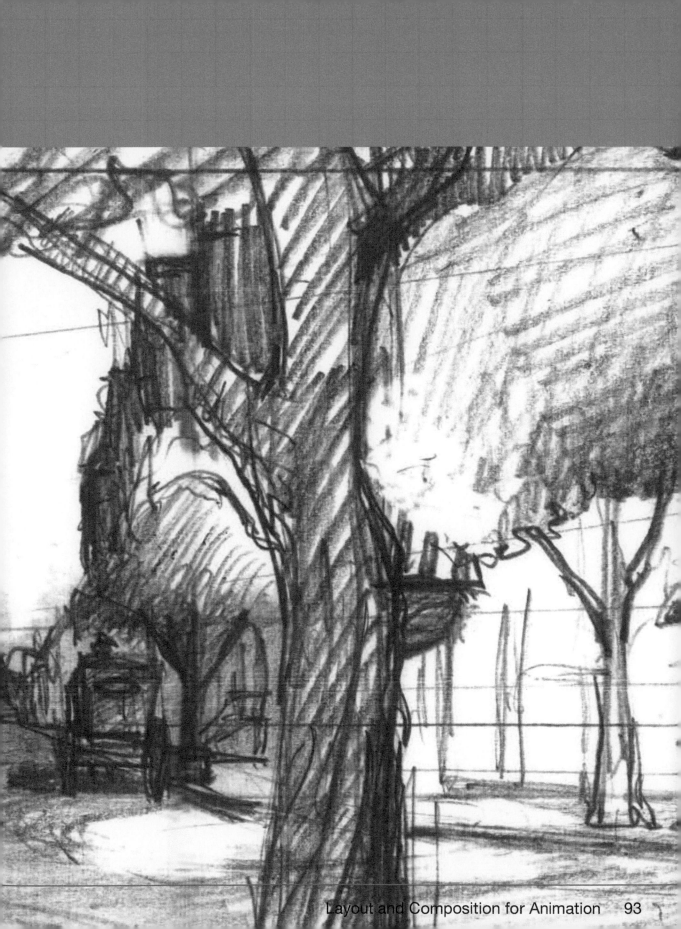

3 Composition

Let It Breathe

- Composing
- Path of Action

Leave air around the character.
Let the scene breathe.

This chapter discusses the physical and emotional compositional aspects of your story and the placement of characters within the setting. Having an understanding of the composition and shapes used to fill the graphic space of your canvas, the relationships between them, and the world you create for them to live in, will strengthen the story point.

Composing

Standards in Film Language These examples are for a standard 1.85 aspect ratio. Widescreen will be tighter.

Extreme Long Shot Full body shape with little or no detail

Long Shot Full body

Medium Shot Waist to top of head

Close-up Top of chest to top of head

Extreme Close-up Eyes

Directional Cues

Placement or position of a character in a scene depends on the direction the character is facing and if it's a single shot. The character should be just to the left or right of center with the center of the field close to an eye of the character.

The examples given show how the third's break-up of space works.

In example 1, the character is in the lower right-third of the frame just right of center. He feels balanced.

Example 2 shows how off-balance the composition feels when this rule is not followed. It feels as though you should expect to see something happening behind and to the right of the character.

Composing

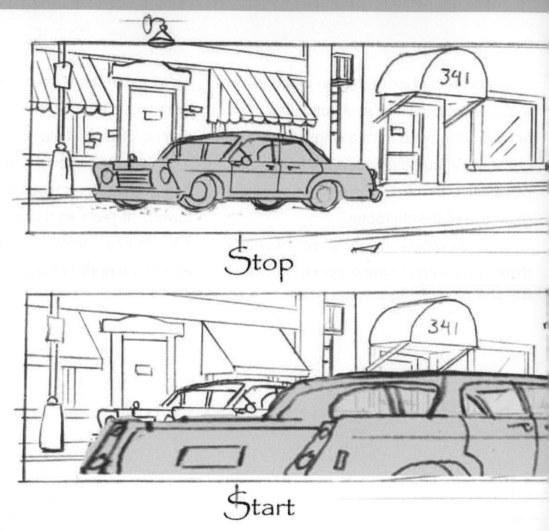

Stop

Start

Make a Statement

Another element that needs to be clarified before composing any scene or piece of artwork is to know what the statement of the scene or painting is.

For example: If a scene starts on a car moving down a street stopping at a storefront, the background at the start position doesn't need as much detail as the stop position (depending on the speed of the car). The background is moving from the

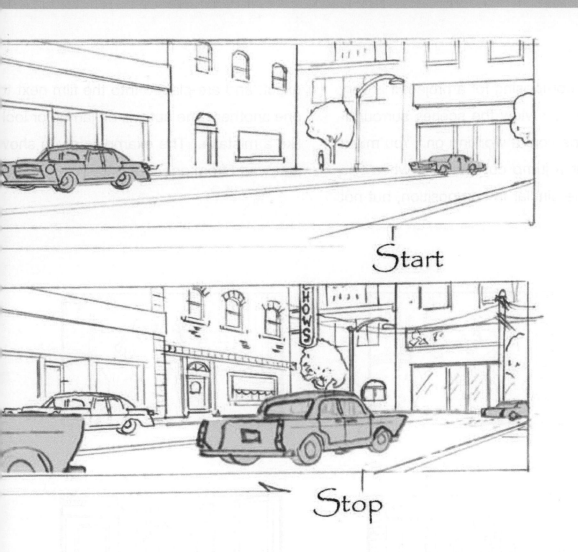

Start

Stop

start of the scene and the car will cover most of it. The camera stops when the detail shows up and usually you'll see this part of the background the longest. Obviously, the reverse applies to a scene that starts on a still and moves to the cut of the scene.

Composing

A Little Bit Jumpy

While composing for a project it is very important to review the scenes surrounding the one you're working on. You might encounter a jump cut which is when two scenes are similar in composition, but not exact, and are placed into the film next to one another. The cut will be jarring or look like a mistake. The examples given show jump cuts from one to another.

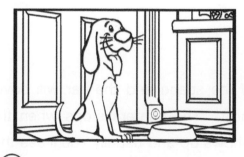

Let It Breathe

These two examples show what "leaving air" around a character means. The space around the character leaves room for acting and movement. Composing a scene too tightly feels claustrophobic.

No Air

Air

Composing

All The Angles

A down shot or upshot push the dramatics of a scene. An upshot is when the point of view of the camera is looking upwards, and the down shot is where the point of view of the camera is looking downwards.

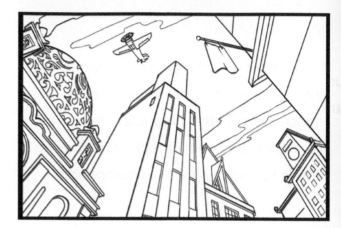

A Dutch angle or tilted angle can be used to give a sense of uneasy and off balance.

Path of Action

Don't Fence Me In

When a character needs to walk through a room, but you don't want to obstruct any acting or movement, it's important to design for that path of action.

In CGI, one can move the camera within the scene with ease, but in traditional 2-D animation you'll need to create scenic overlays that make it seem like a character is actually walking through the world you've created.

Path of Action

Out of the Box

Not all shapes have to, nor should they, be confined to the format you're working with. Allowing a shape to fall outside the working area implies a deeper space. If everything is neat and tidy in a field, it makes the world you're trying to describe small as if you're looking through a window.

Nature Abhors a Flat Plane

A common mistake a layout artist creates is to design a landscape with a flat ground plane. Nature doesn't appear flat anywhere. Man will cut areas flat, but even then, streets slope toward the curb so rainwater will clear the street. When laying out a scene if possible it's a good idea to place a perspective grid in the scene so other departments can use it. The red line indicates the path of action the animation will take.

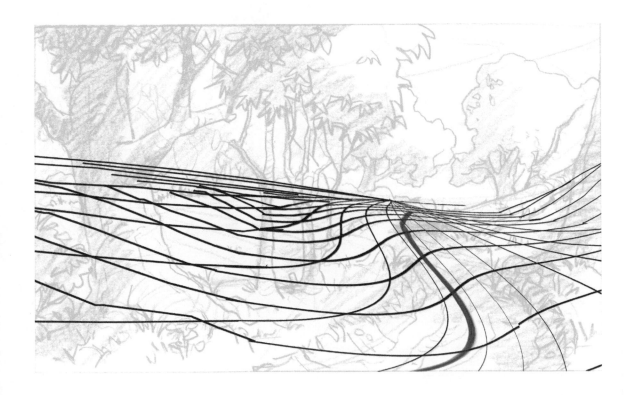

Path of Action

The Thin Blue Lines

While the animation is being cleaned up or finalized in computer graphics, the layouts get cleaned up and a pro- cess called blue sketch will be next in the traditional process. A blue sketch artist will take the animation and the cleaned up lay-

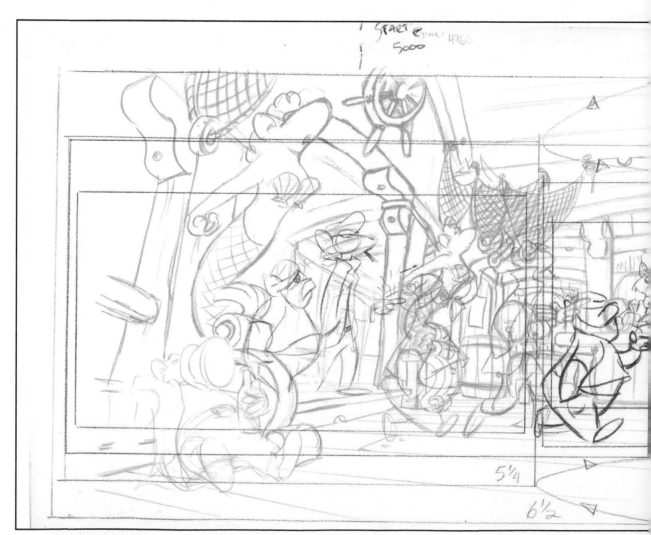

out and create a composition with the key drawings on one piece of velum (transparent) paper. This set-up will be used by the background artist to see the path of action so the painter knows where to paint the details to be best used.

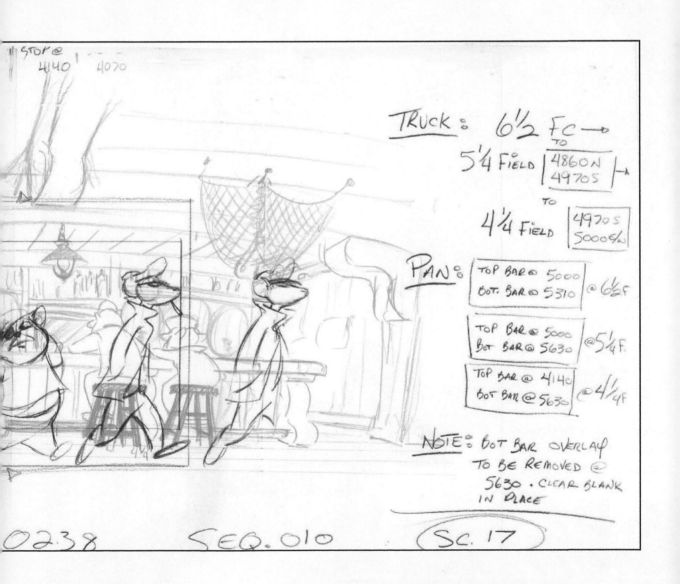

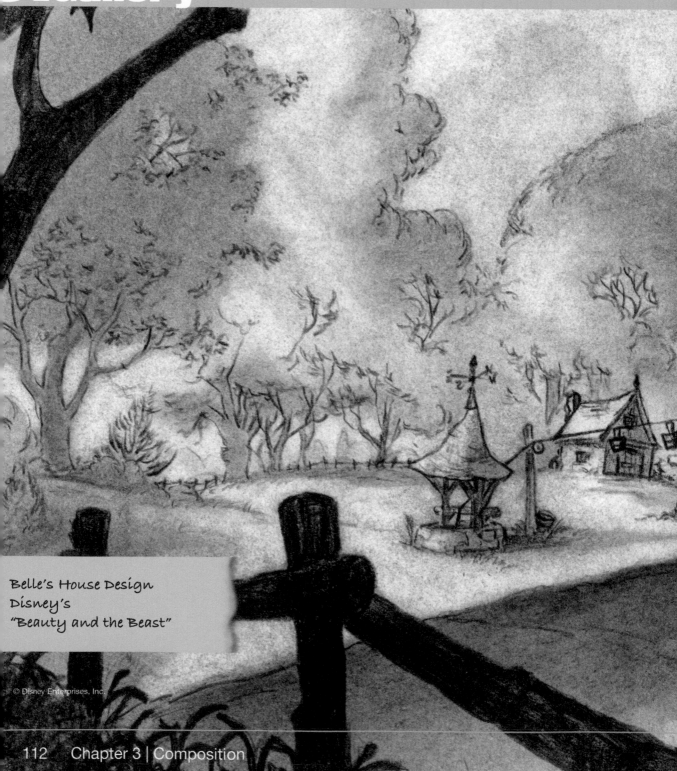

Belle's House Design
Disney's
"Beauty and the Beast"

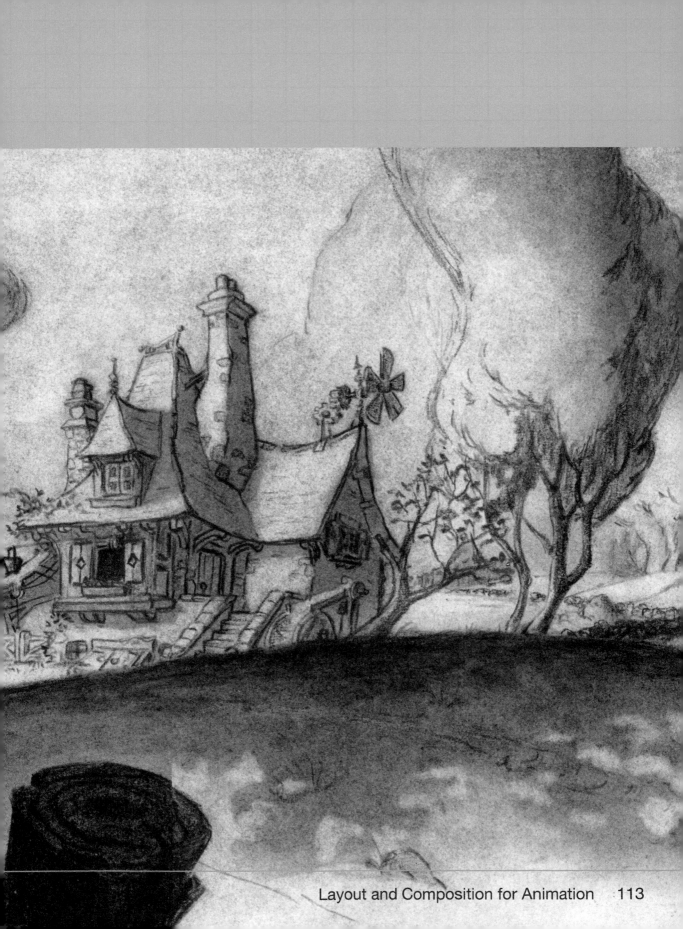

4 Camera

Disneyland Pre-Show
for Circle-Vision
"ALL BECAUSE MAN
WANTED TO FLY"

DRAFT NO. Ruff #1 PAGE NO. 1 DATE 7-15-8?

PROD. NO. 5910-082 PROD. TITLE

SEQ. NO. SEQ. TITLE LAYOUT MAN Ed Ghertner SEC'Y Pam Distaso

DIRECTOR Dave Michener ASST. DIR Greg Shepard

SCENE NO.	ARTIST	SCREEN FOOTAGE	B. G. DATA	DESCRIPTION OF ACTION
1		22-00	Card	Theme Music begins. MS - Projection screen. A "Click" sound effec? is heard and the title All Because Man Wanted To Fly appears on the screen. Orville (O.S.): (Humming along with the musi? "Click" EFX and titles change to As Told By ? Expert In The Field... Orville (O.S.): (Humming along with the mu? "Click" EFX and titles change to Actually.. An Expert Who Flies Above The Field... Orville (O.S.): (Humming along with the m? "Click" EFX and picture changes to Your Ho? and Narrator... Orville (O.S.): (Humming along with the mu? "Click" EFX and titles change to Orville. MCU - Orville the Albatross as he steps int? frame. Orville (Singing): "ALL BECAUSE MAN WANTE? TO FLY!" (Laughs) Orville (Spoken): "HOWDY FOLKS, I'M ORVI? SAY, LET ME SHOW YOU W? I'VE BEEN CHOSEN..." ? "Click" EFX and picture changes to:

Existing (from The Rescuers).

?ntinuing to run along runway.

?ville: "YOUR A1 AERONAUTICAL EXPERT!"

FIELDS

• Grids and Guides

ALL THE RIGHT MOVES

• Camera Movement Arrows
• Vertical Pans/Horizontal Pans
• Crossing the Line
• Moving With the Camera
• Match Cuts
• Bi-Packs
• Straight & Bezier Movements
• Slow-in/Slow-out
• Repeat/Peg-over
• Multi-Level/Multi-Plane
• Overlays & Underlays
• Compositing
• Simulated Multi-plane
• Held Cell
• Backgrounds

This chapter

shows how using different camera placements can create emotional results. It also shows the importance of clarity in composition as to not confuse or misdirect the audience. The camera is the audience's window into a new world, and layout artists are animation's cinematographers. Guide your viewers through your world and don't let them get lost!

Fields

Grids and Guides

"Fields" are the frames of a composition the camera will see. Field guides will usually be numbered from a 4-field to a 16-field. The numbering comes from the horizontal distance within the field; a 4-field will be 4 inches wide and so on. The field guide has a cross hair marking to show the center of the field and the projection cut-off. (Depending on the projector, the cut-off refers to the portion that will be cut-off or not seen on the screen.) The center of the field will have a numerical value that collates to a field grid that is pegged and positioned with the artwork.

North, South, East, and West demarcate grids in traditional animation. Each line of the grid will be numbered from the center out starting with the number one. The difference between traditional animation and computer graphics numbers is that CGI numbers are positive North, negative South, West is negative, East is positive, and Away ("Z" plane) is negative. Any movement toward the camera is positive.

The field guide is placed on the grid for the position numbers in a still shot. If there will be a camera move, then the first position numbers are written on the exposure sheet. The field guide is moved to the next position, and that second set of numbers is written down. The Scene Planning Department will configure the move from these two sets of numbers that are written on the exposure sheet as instructions to the Camera Department.

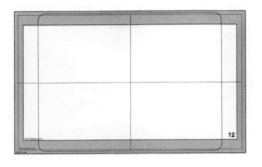

Field Guide

Field Grid

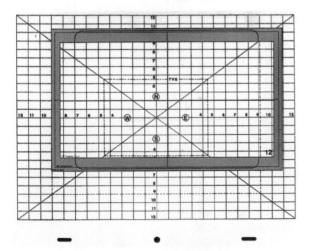

Field Position #1 is: 2 North/ 1 East

Field Position #2 is: 3 South/ 1 West

All the Right Moves

Camera Movement Arrows

In storyboards or layout drawings, arrows are used to describe camera moves for the camera positions or "field". In traditional (2-D) animation, sideways movements are referred to as "pans," and movements towards the artwork is known as a "truck-in".

Movements away from the artwork are referred to as "truck-outs."

Movements in the virtual camera (CG) use the letters X,Y, or Z to describe the camera action.

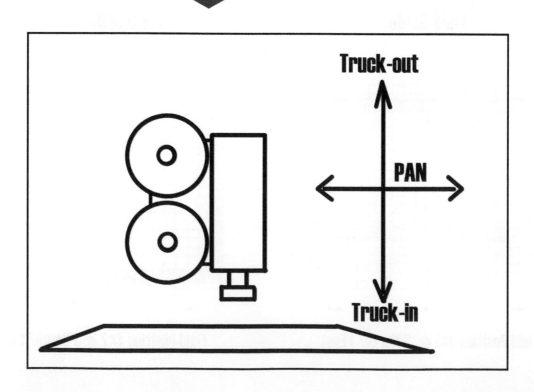

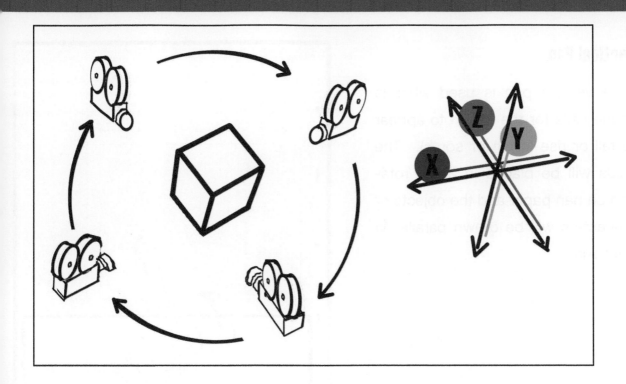

Traditional and Computer Graphics animation use the same basic camera principles. Traditional animation camera is limited in its movement capability, the CG camera is not. The digital camera has given 2D animation the capability to do much more movement and tricks over the traditional mechanical camera. In my opinion, the ability to have as many levels, or layers of artwork, as necessary and to adjust each level independently with only one camera operator are the biggest attributes of the digital camera.

All the Right Moves

Vertical Pan

A vertical pan is used when a scene calls for the action to appear to fall or rise (north or south). The fields will be placed in a 90° rotation on pan paper and the objects or characters will be drawn parallel to the pegs.

Horizontal Pan

A horizontal pan is used when a scene calls for the action to appear to move side to side (east/west). The fields will be placed horizontally on pan paper. The movement can be created one of two ways: the camera moves horizontally across the artwork, or the artwork is moved horizontally under the camera.

All the Right Moves

Crossing the Line

"Crossing the line" is a term used in live action film. It refers to the understanding that two characters or objects in a shot or sequence should always have the same left/right relationship. It is as if an imaginary line cuts through the scene just at the action. If the camera crosses the line and photographs from the opposite side of this imaginary line without the provision of a proper visual transition, the action will appear to flip and move in exact opposition from cut to cut which can be extremely confusing to the audience.

Of course, in animation, there is no physical way for the camera to cross the line; however, drawings can be set up improperly in a way that causes this same problem. Crossing the line usually happens at the storyboard stage in animation. However, a positive attribute of animation is that these mistakes, if not caught in storyboard, also pass through a number of continuity checks. Therefore, bad staging and composition are usually caught before images are committed to film.

The illustration above shows where the imaginary line would be in relationship to the action. In live-action, the camera only shoots within the 180° area shown here in red. In animation, images must be drawn so that they also appear to not fall outside of this guideline.

This is what the action would look
like when shot from the correct side
of the imaginary line...

...and then from the far opposite
side of that same line.

All the Right Moves

Moving with the Camera

Artists often move the camera too much. In most cases a little goes a long way, and too much can ruin good dynamic action.

As an example, if a character is moving diagonally toward camera you really don't want the camera doing the same movement, as that cancels the character action.

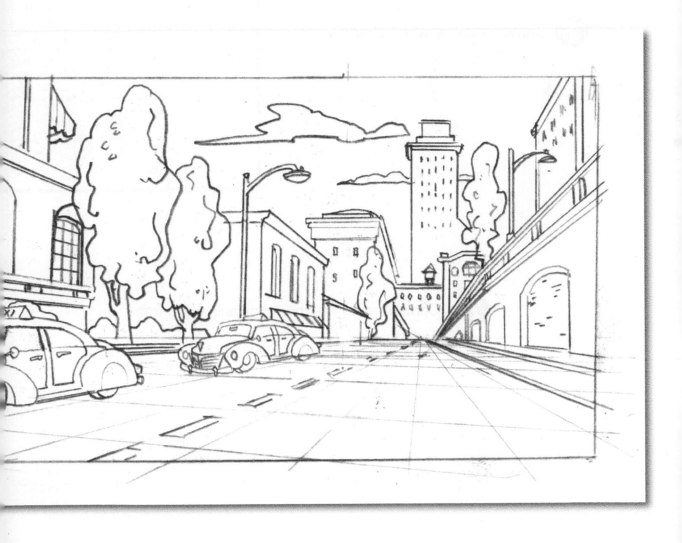

All the Right Moves

Examples

1 Camera moving with action.

2 Camera still with character animating into camera.

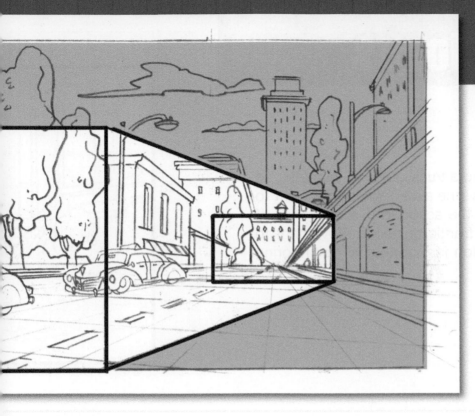

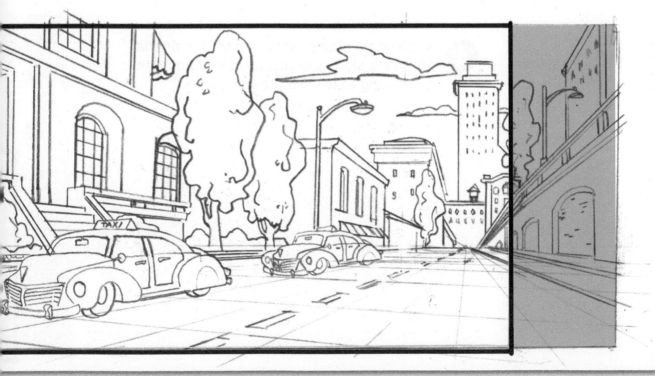

All the Right Moves

Examples (cont'd)

3 Slight camera truck-out with animation to keep the scene alive. You might want to use this if the action in this sequence of scenes is frantic or needs movement to match action for hook-up to neighboring scenes.

4 Truck-in on character. Us this if the animation feels slow and you want it faster without having to re-animate the scene.

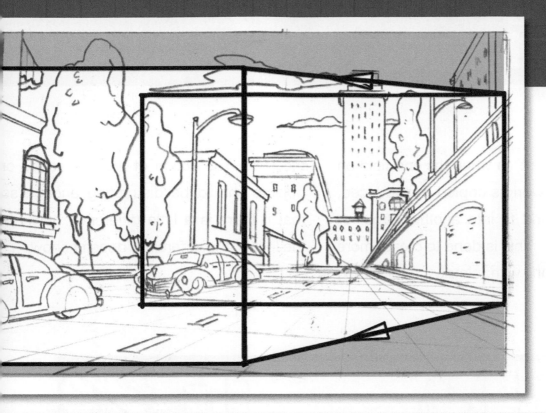

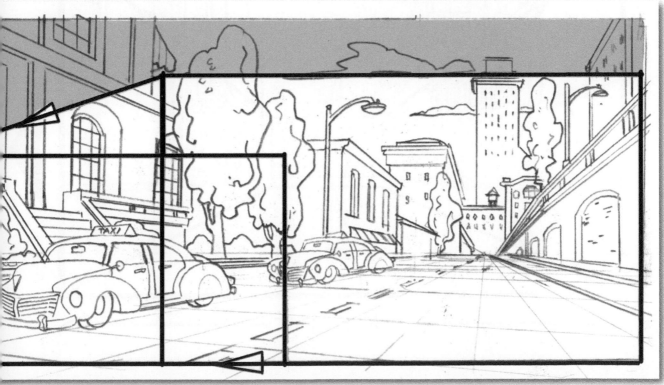

All the Right Moves

Match Cuts

A "match-cut" is when the end field on a piece of artwork is copied and reduced, or enlarged and fit into another larger or smaller piece. This is done to create more canvas to work with; simply cut between the two. The action of the characters or objects should be distracting enough so that if there is a little difference between the levels, the difference doesn't show.

Scene One

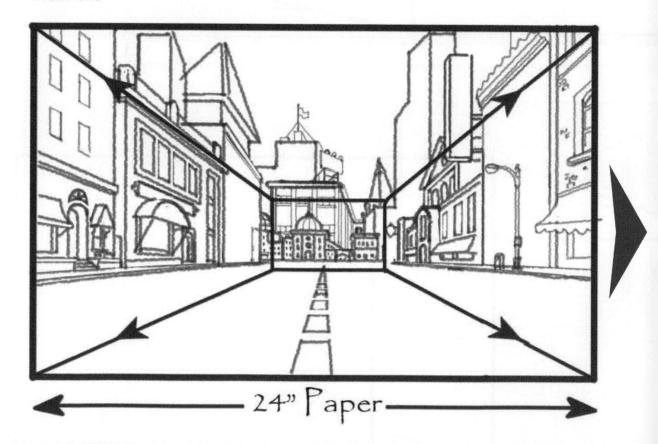

24" Paper

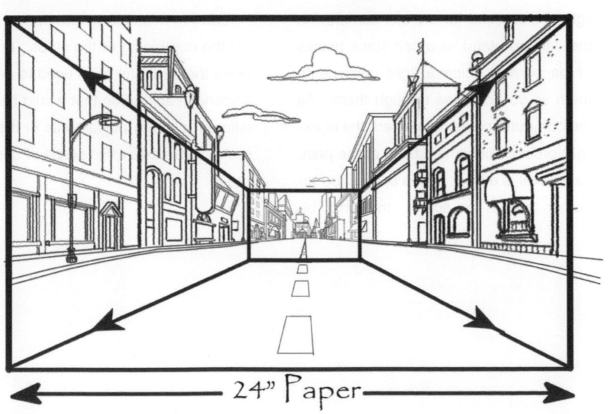

Scene Two

This field is the end field of Scene 1 and the start field of Scene 2.

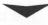

24" Paper

All the Right Moves

History of the Bi-Pack

In the traditional 2-D animation camera, there is a way to create a hot glow effect for final production, and that is to backlight the effect in the camera. This is done with a hole or design in black paper where a light is shined through from behind or underneath the art. The backlight is also used for the test camera. In the camera stand, you can stack pieces of paper and shine a light underneath them so you can see through them. As the computer came to be used, the backlight process became a thing of the past. Each level is a layer that is composed together to form the scene. the term "bi-pack" is similar to what happens in the computer. Bi-pack comes from an earlier camera technique where the camera person would load two or more rolls of film in the camera's magazine, one strip that is exposed and a raw film strip that will be exposed with the effect.

Later in filmmaking, the optical printer did the combining of the strips. In recent years the term has been used to describe a scene in animation that would have two different camera placements in the same scene to create a false sense of depth.

Strip 1 is a house that is being photographed.

Strip 2 is a fire shot in an effects house to scale.

In this scenario, a still of the house was shot so the effects people could create fire coming out of it. That roll of film was then placed in the camera and the camera person shot the house with people running out of it. As both pieces of film ran through the camera, the second strip of film picked up the fire as well as the house and people.

All the Right Moves

Bi-Pack for Animation

Here's an example of a simple bi-pack in animation. The camera moves are different for the foreground tree and characters to the background hills and trees.

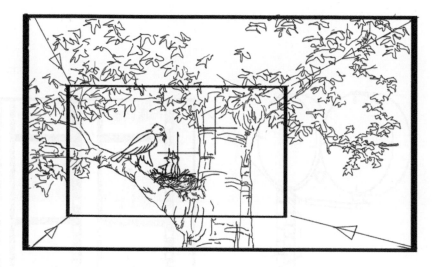

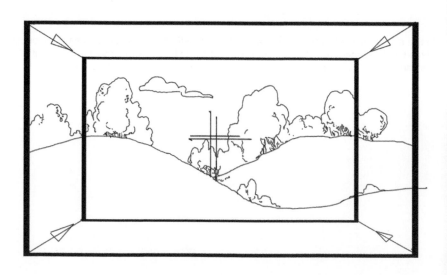

Straight and Bezier Movements

A straight forward camera move from point to point will be a straight line on the computer camera's graph window with no slow in or slow out. To create a soft move, a bezier move is used. A bezier is a camera move that is controlled by adding points on a line between the start and end of a move and sliding those points to create and modify the move's appearance.

A camera move that is at a constant speed throughout the scene.

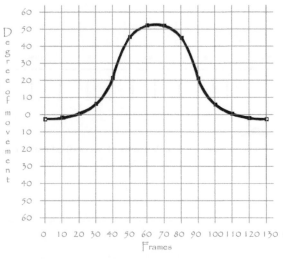

A bezier curve where there are many points on a line allowing you to slow the move or speed up the move according to the action.

All the Right Moves

Slow-in / Slow-out

When creating the camera move you have the ability to move the camera (naturally) objectively by starting slow and gaining speed or moving at speed from frame one. Start slow and move faster is referred to as a "slow-in." A "slow-out" is the same as the "slow-in," only it takes place at the end of the move instead of the beginning. Most times, both slow-in and slow-out are used within a single camera move.

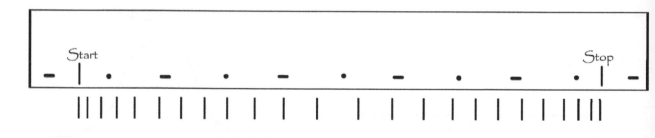

This is an example of a 24-frame (1 second) camera move with a slow-in and out. Each tick mark represents a frame and where the artwork would be placed for each frame.

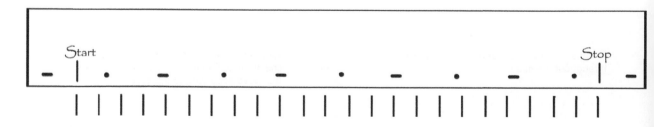

This is an example of a 24-frame (1 second) camera move at speed from start to stop. You can see that the spacing is even between the tick marks.

Repeat / Peg-Over

Sometimes in animation, a character is moving so fast that a background won't be long enough to cover the whole scene, so what you can do is make the first and last fields of the artwork the same. When you get to the last field, you move it to the first field and start the move all over again. The peg-over refers to the center peg of the artwork. When repeating, you are putting the center peg of the artwork onto a different peg on the camera bar.

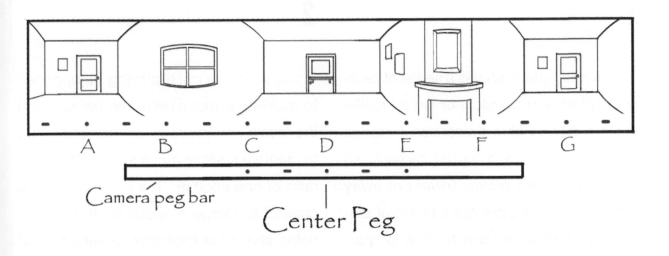

The pan below is an example of a repeat pan/peg-over. If you start on "A" peg and pan to "G" peg, then take the artwork and move it back to "A" peg, you can create a background that will go on for as long as you like because the 1st field and the last are the same.

All the
Right Moves

Multi-Level/Multi-Plane: The Parallax Effect

1

2

The multi-plane shot is a series of pieces of artwork in physical or virtual reality that are placed at a prescribed distance from each other and to the camera, so when the camera moves toward or away from the artwork it creates a sense of distance or depth. A term for this is "parallaxing," when objects appear to move faster in the foreground as to the background but are locked to the same vanishing point. In multi-planing as opposed to multi-level movement, the camera and the levels can move in any direction, but to create a realistic move all should be in a ratio of one another. If a camera move is created in computer graphics, the models being shot have their own dimension and you will not be dealing with flat levels parallel to the camera lens. The movement will have a natural parallaxing.

3

4

Parallaxing is a major component in the 3-D process. In examples 1 through 4, the camera is moving left to right and rotating counter-clockwise showing how the sign in the foreground moves across the screen faster than the mountains in the background with the castle and the cone moving in ratio between the two according to their distance from the camera. In the construction of the 3-D process two cameras are used or two points of view are being seen at the same time. To the naked eye the image is blurry and unwatchable, but with the help of special glasses the observer's eyes are focused on each camera separately, giving the viewer a hyper-parallaxing view of the picture.

mountains

castle

cone

- sign

camera 4

camera 1

All the Right Moves

Multi-Level

An animation camera move can imitate a real camera move in many different ways, but the three most common are Multilevel, Multi Plane, or Virtual Reality (CG). With regards to the CG camera you will use the same thought processes as the 2D multi-level and multi-plane moves, only the camera will be moving around the object just as in live action, whereas the multilevel camera move has the camera static and the levels move parallel to it. The final look has depth to it because of the levels of art sliding across one another. The multi -plane camera move is a compound move, meaning that every artwork element and the camera can move in any direction. The examples show how this works.

The multi-level move shows a bird flying over clouds and a countryside so the bird is static to the camera animating. The clouds are moving faster than the background because of the space or depth between them and the bird. To give a sense of the bird moving faster the clouds can be moved faster. As the bird dives down to land, the cloud level and the bird levels will switch positions to the camera, and with a four-to-six frame cross-dissolve, the bird will appear to have traveled through the clouds. If there were no cross-dissolve the animation would pop off and not look right.

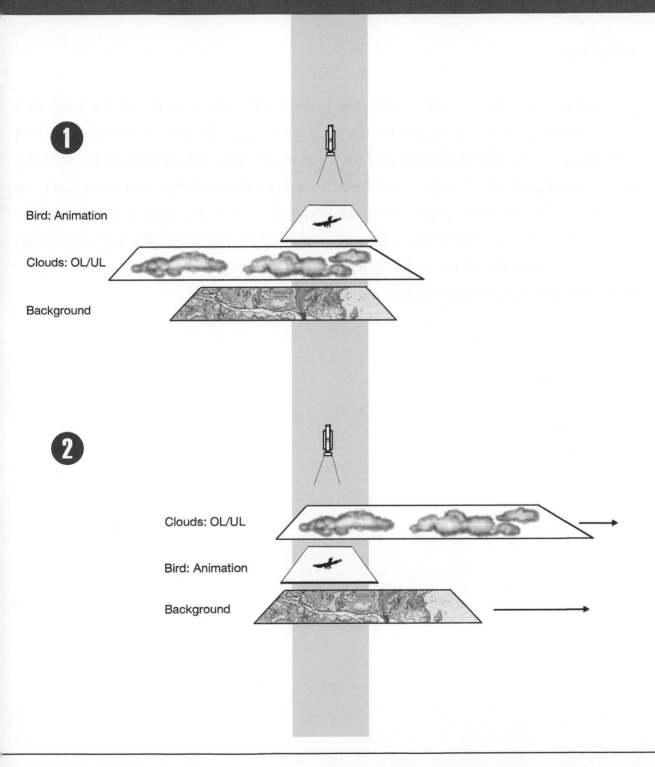

All the Right Moves

Multi-Plane

The multi-plane move has the bird close to the camera and the other elements farther away. As the scene progresses, the bird level will pan to the right of the field as the clouds and the background move to the left. At the same time the bird level moves away from the camera slightly and the cloud and background levels move toward the camera. The camera will also move toward the right to follow the action of the bird as well as moving towards the background. All these moves should have varied speeds all relating to one another and will be set up by the scene-planning department.

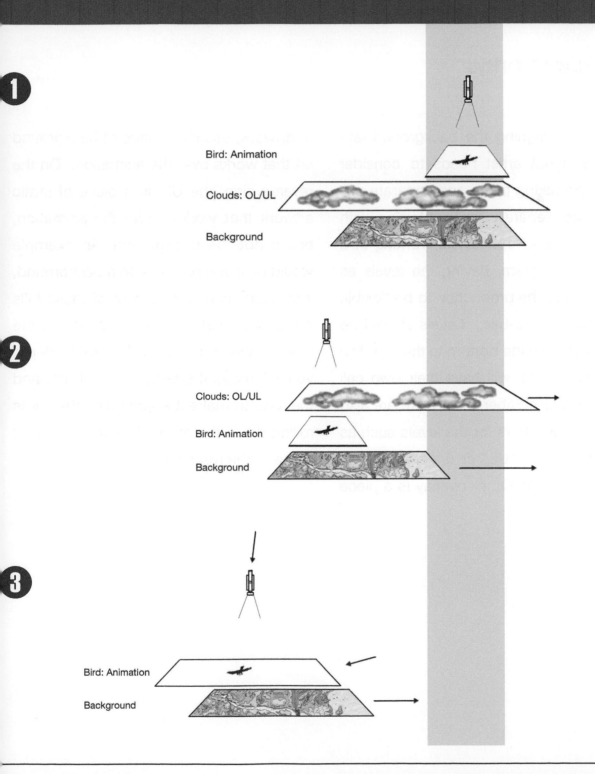

1

Bird: Animation

Clouds: OL/UL

Background

2

Clouds: OL/UL

Bird: Animation

Background

3

Bird: Animation

Background

All the Right Moves

Overlays and Underlays

When designing the background layout the layout artist needs to consider the action taking place and separate objects onto separate levels starting with the background up. While working in a computer program, having the levels as layers allows the production to be flexible to changes or re-use. Levels should be numbered from the bottom to the top. The levels of artwork will have their own call letters and/or numbers, but there are also standard call letters for the levels such as "OL" or overlay, "UL" or underlay, BG or background. An OL or overlay is a piece of artwork, usually a piece of background art that works over the animation. On the reverse side, the UL, is a piece of static artwork that works under the animation, but is not the background. An example would be if you had hills on a background, and positioned just in front of these hills are another set of hills and a car on the road in the foreground. To create depth you will move the second set of hills and the road to make it appear as if the car is rolling down the road. The second set of hills and the road would be a UL.

Overlay: Grass

Animation: Car

Underlay: Road and Hills

Background: Hills and Sky

All the Right Moves

Compositing

Traditional camera is the compositing tool in 2-D. Once a scene is shot, it can't be further manipulated. To change the scene would require you to shoot it all over again. In CGI, the ability to manipulate the levels before final output is unlimited.

Here is a sample of the desert hills and road to show how separate levels are composited together in traditional 2-D animation. The example also shows how the individual layers are moved to create the action. Here you can see that the top layer (animation of the car) has been moved right across the screen while the midground level (shown here as hills in light brown) was moved left. The background and road both stay stationary throughout the shot.

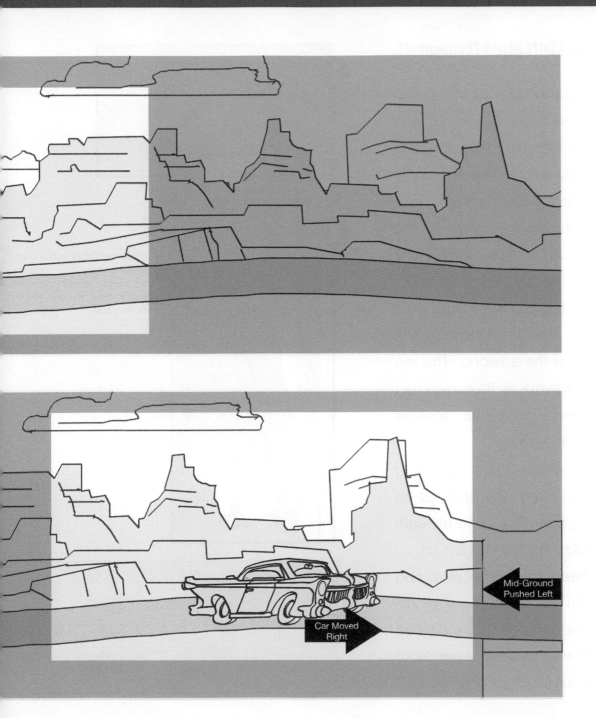

All the Right Moves

Simulated Multi-plane (Compound)

With the limitations of 2-D you sometimes have to do camera tricks to simulate a multi-plane shot. You might create multiple set-ups within one scene or shot. To accomplish this, you set the shot up as multiple levels with physical, empty holes in them so when the camera trucks in, it is pushed into the field past the top level of the artwork. The top level of artwork is then removed as camera continues forward through the levels.

To eliminate blank space in the background, the next set-up or background is placed beneath the window for the first set-up.

To keep the scene alive and active, in the example, I've rotated the camera (#1, indicated with arrows) to keep a sense of off-balance.

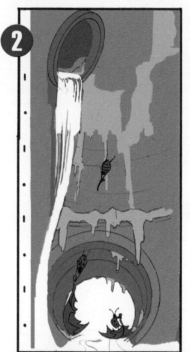

Three individual setups are created, but the camera will move through them as though they are one single moving shot.

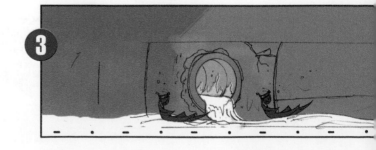

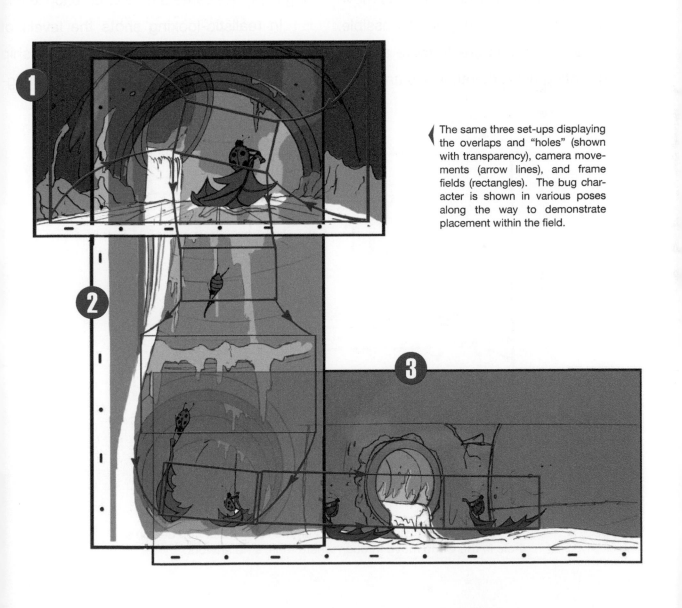

The same three set-ups displaying the overlaps and "holes" (shown with transparency), camera movements (arrow lines), and frame fields (rectangles). The bug character is shown in various poses along the way to demonstrate placement within the field.

All the Right Moves

Here's another example of how to move the camera farther than physically possible. In this case, you can create more artwork by separating artwork into levels and add-ing separate camera moves on each level.

In realistic-looking shots the levels of artwork should all be in ratio or relationship to one another, but a cartooned or exag-

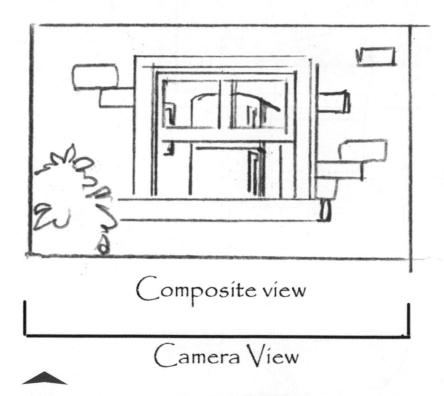

Composite view

Camera View

To go through the window and end on the refrigerator you design a hole in the OL to move through where there's no artwork.

gerated look can be achieved by putting totally independent moves on each level.

This example is a shot where the camera is supposed to go through a window into a kitchen and stop on a refrigerator door.

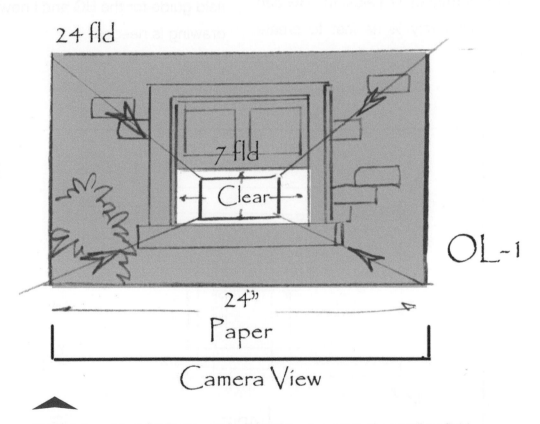

24 fld

7 fld

Clear

OL-1

24"

Paper

Camera View

Start at the widest field you can so that when you get to the smallest field (as a standard, you don't want to get smaller than a 7 field or 7 inches wide) the detail won't look huge on the screen. The line work or painting won't hold up when you get too close to it.

All the Right Moves

The second part of the camera move will be on the BG. The BG can be on smaller paper because the OL will cover most of it. Since the OL is moving from 24 field to 7 field at a total of 17 fields, the BG can move approximately ½ as fast to create a sense of depth. If this is the case, the BG will move 8 ½ fields. Figure out what field you'd like to end on, back the camera out to 8 ½ fields and you'll have your field guide for the BG and know how much drawing is needed.

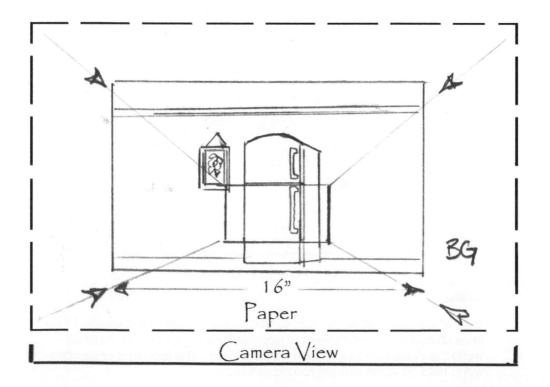

16"
Paper

BG

Camera View

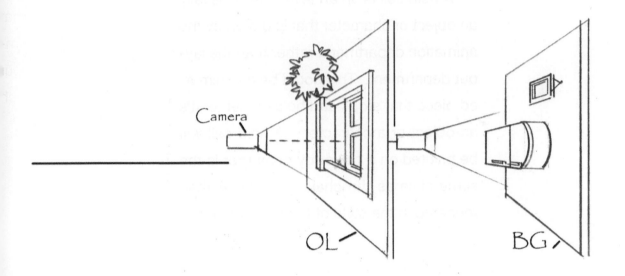

The drawing above describes the placement of the camera
to the OL and BG levels if they were in the real world.

All the Right Moves

Held Cells

A held cell is an art level that is usually an object or character that is drawn by the animation department, rather than the layout department. This could be an animated piece that stops and holds whether it's an object or a character. A held cell will be painted on a cell or by computer in the same style as the characters rather than rendered in the style of the background.

All the Right Moves

Backgrounds

The furthest piece of artwork from the camera, excluding characters and effects, is the background. The final version of the background is painted in the background department, but is designed by layout; first as a rough version, then a cleaned-up linear version, and finally, a rendered version that shows the various values within the layout.

The process is similar in computer graphics: a concept design then elevation drawings are created, top, both sides, front and back of any objects to be built in the computer. To save money and time, backgrounds are occasionally painted on a plane and placed the farthest away from the CGI camera in a manner similar to 2-D.

Rough Linear

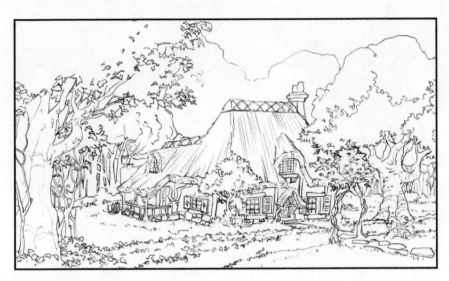

Cleaned-up Linear

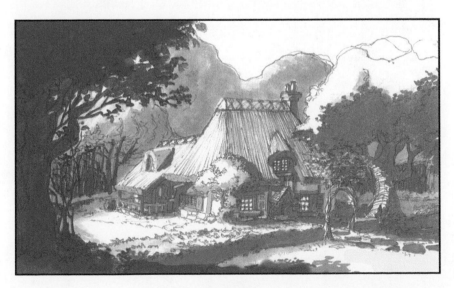

Rendered

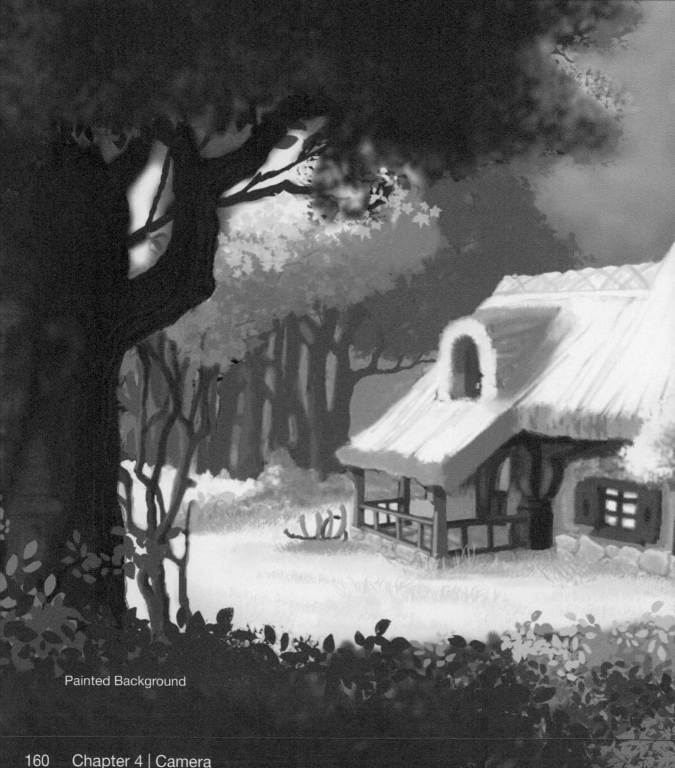

All the Right Moves

Painted Background

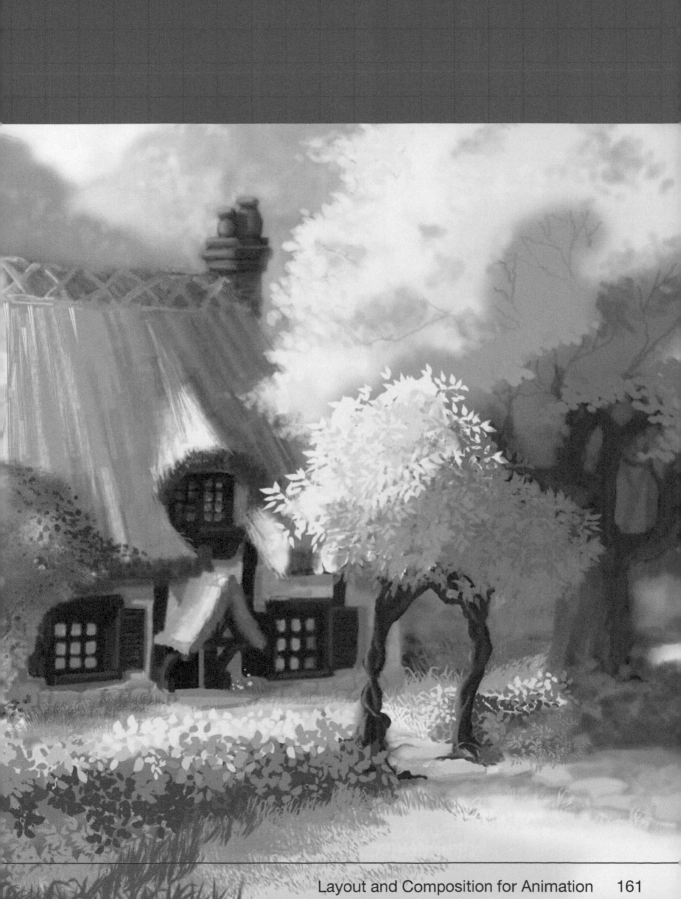

Interior
(Pencil & Color Renderings)
Disney's
"The Black Cauldron"

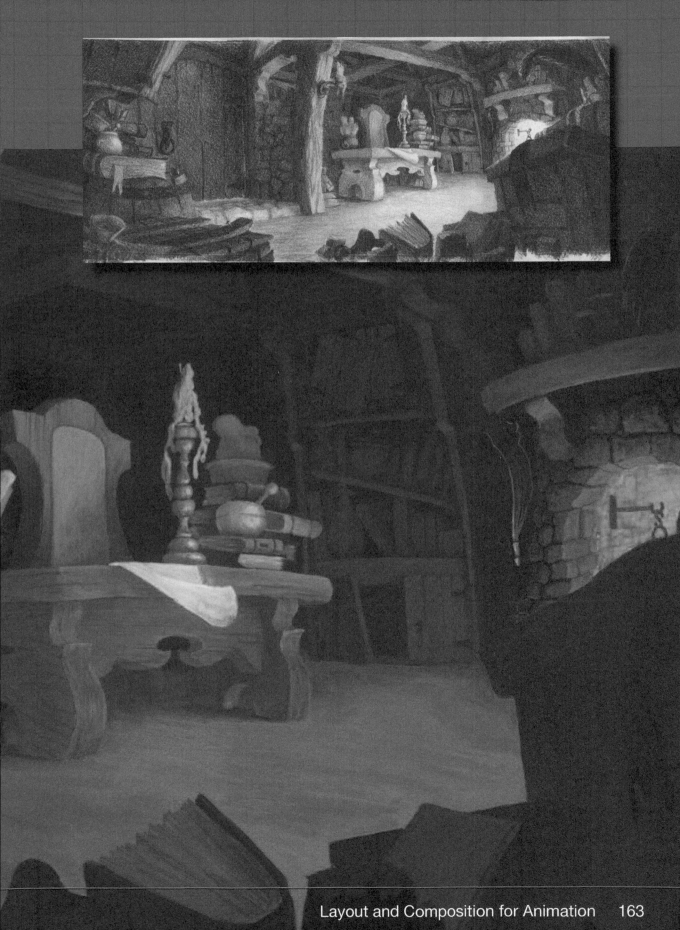

5 Lighting Effects

- Effects
- Shadows
- Gradients
- Reflections

Lighting,

shadow, and reflection create dimension in a composition, and it can also be used as a tool to direct the eye to a certain point on the stage. As a design element, a shadow establishes volume, creating "more" than actually exists in a composition. It also helps to set up the mood and meaning in a scene.

ffects

A Little Goes a Long Way

You have to be responsible for production costs and the look of the picture or show. When dealing with lighting, you can create a lot of extra work for the effects department, which will increase the cost of the production.

So remember, a little goes a long way. By definition, an effect is something that should happen because it is needed, not just because you can put there. For instance, in the case of a character that walks down a hallway where there is a pool of light from a nearby window, only place contact shadows through the light to the floor with no highlights on the character. Just a color change of a shade or two darker or lighter as the character walks through light and shadow. To have highlights and contact shadows throughout the scene is a waste of time and money. The effect will be stronger by having a few frames of high detail and then back to a simple statement or even a silhouette.

Exterior scene with pool of light created by incandescent light.

Internal scene with pool of light created with sunlight.

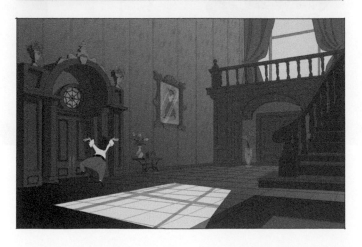

Shadows

A Little Goes a Long Way

Lighting is an important design element to a composition and unless there's a story point, I prefer not to have the main light source on screen. Reasons being that it will create a focal point because it will have the highest contrast in the design and take away from the lead character.

There are exceptions to every rule.

While a light source behind a character can create mood, it can be just as effective as a stand-alone element in a scene as shown below. What I would do in this case is to drop the contrast on the light and let the character's eyes have the highest contrast.

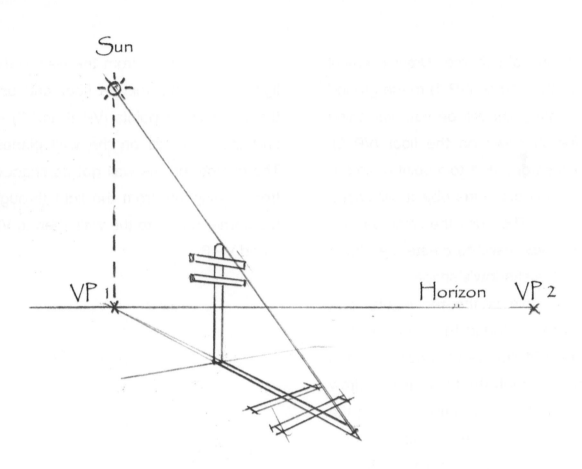

Shadows emanating from sunlight are always 45 degrees from the sun to the top-most point of the object to the ground plane.

To achieve this, draw a vertical line from the sun to the horizon for the vanishing point for the shadow. Then draw a line from the sun through a point on the top of the object, in this case the telephone pole to the ground. Then draw a third line from VP 1 to where the two lines cross.

Shadows

Incandescent Lighting (Bulbs)

Find your light source. Draw a vertical line from the course (VP 1) to the ground plane. That point will be your vanishing point for shadows on the floor (VP 2). Draw a line from VP 1 to a point of an object onto any plane the object will cast a shadow on. Then use the same vanishing points you used to create the object to define the shadow's shapes.

An example is the rectangular box on the floor. I found the diagonal lines from the light source to a corner of the box, then through the floor. Next I drew a line from VP 2 on the floor through the bottom corners of the box, and so now we have two intersecting lines. Take a straight edge from that point and match to VP 4, the vanishing point on the horizon we used to create the box and draw a line. Now you have a shadow shape on the floor. Repeat these steps for all the other objects.

To get the shadows for the walls, draw perpendicular lines from the wall to the light like we did for the floor and use these vanishing points (VP 6 and 7) to find the shadows on the wall planes. The cabinet on the wall got its shadow from a diagonal from the light through the corner points to the wall, then to VP 5 and VP 6.

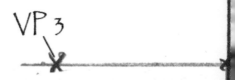

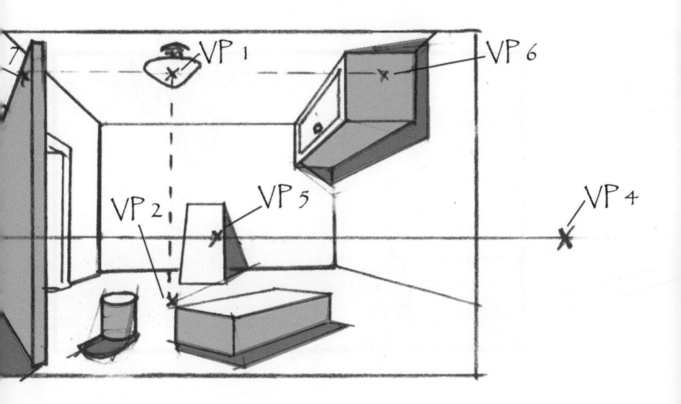

Shadows

Shadows will be defined by how close the object is to the ground plane. The example below shows the shadow of the three and fire hydrant. The top of the tree is approximately 20 feet off the ground and the hydrant is only about 3 feet from t[he] ground. The closer to the ground plane any plane the shadow will be cast on, t[he] darker and sharper the shadow will be.

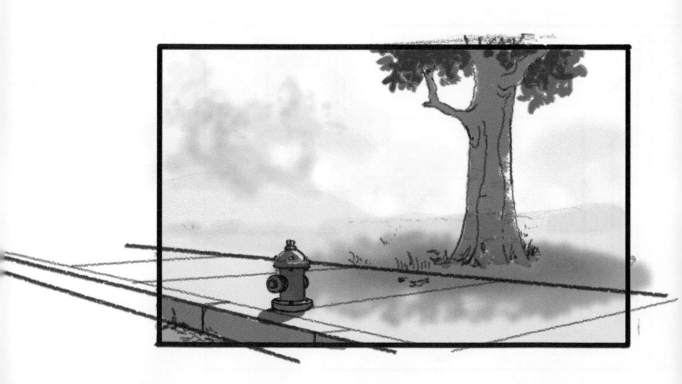

A shadow can be used as a compositional shape device. The example below would be very flat and boring because of the large wall plane in the midground, but the diagonal shadow I placed on the right side of the drawing brings your eye back toward the character and creates depth with values. Plus the angles of the shadows meet where the person sits. This is an example of a "good tangent," when you want to create a focal point.

Gradients

Turn Up the Volume

Gradients can serve as another way to "turn up the volume" in your compositions. For instance, you might find yourself needing to render the wall of a house with wallpaper. A simple way to do this is to take the shape of the wall and render it with a gradation from dark to light from the top to the bottom of the wall. Give the detail of the paper a medium value. This will create dimensional look. It will go from light over dark to dark over light as in the example shown. This is very tricky in a traditional drawing, but by creating the wall shape in a computer program such as Photoshop, with your gradation on one level and the wallpaper design on another, you can easily adjust the values of each layer to get the effect you desire.

Reflections

Reflections are mirror images of objects at the point where the plane of reflections sits. With the advent of computer programs where you can flip artwork vertically, it's much easier to create reflections. Even though this is possible, you still have to manipulate the artwork at the point where the pieces meet.

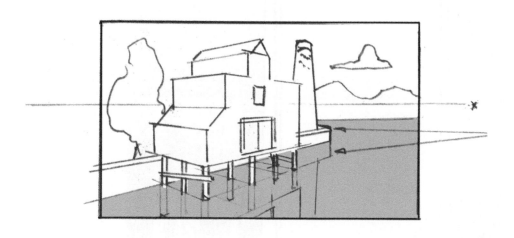

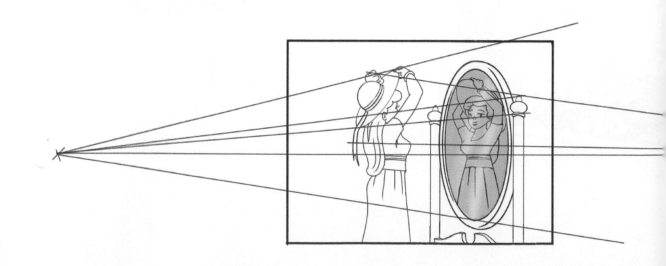

I've placed a vertically flipped copy of the artwork here to show how much I manipulated the art.

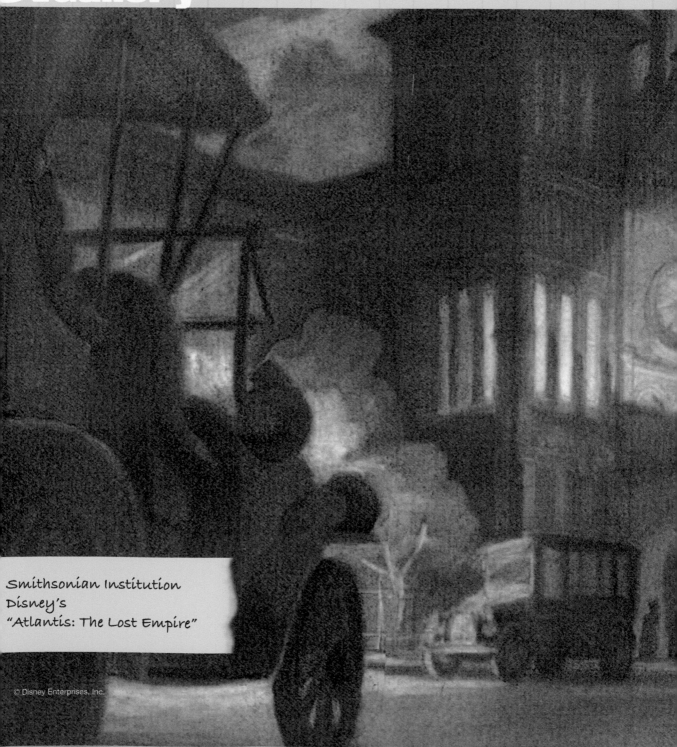

Smithsonian Institution
Disney's
"Atlantis: The Lost Empire"

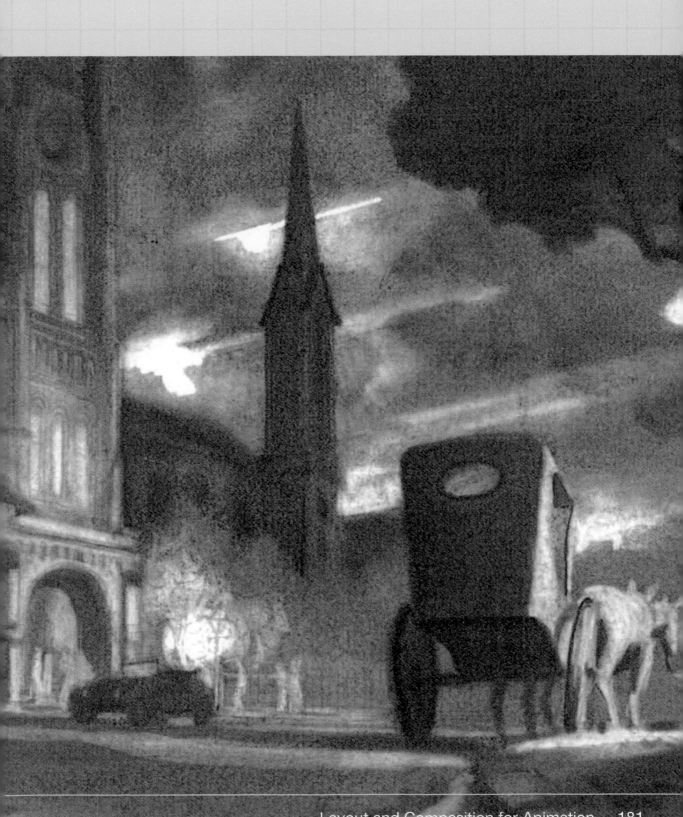

6 Workflow

This discussion of workflow takes you through the entire process of animation step-by-step. It shows how different departments and artists often work together and that the process is not linear. There are many checks and balances in a collaborative art like animation, and understanding how things work together helps clarify the best way for you to do your part.

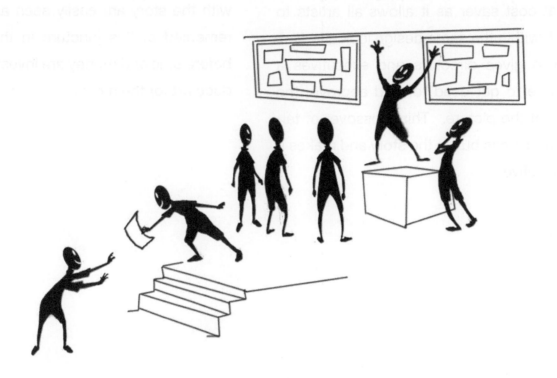

Workflow

Development

At the start of development when the story is being polished, the designers are brought in to help create the physical world in which the story will be told. This is a great cost saver as it allows all artists to work within the same design look and feel. It also gives directors and executives a chance to get used to, and approve, the look of the picture. This crossover of talent and ideas builds the story and makes it come alive.

Pre-Production

Storyboards are shot and edited wit rough dialogue and timing into a story ree Unrefined as it is, this is the first time th story is told with visuals. Any problem with the story are easily seen and can b remedied at this juncture in the proces before time and money are invested to pro duce art for the movie.

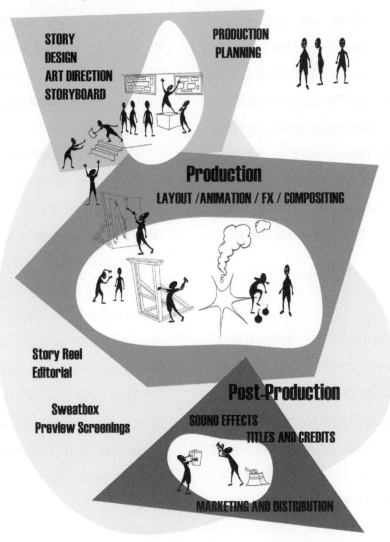

Development / Pre-Production

STORY
DESIGN
ART DIRECTION
STORYBOARD

PRODUCTION
PLANNING

Production
LAYOUT /ANIMATION / FX / COMPOSITING

Story Reel
Editorial

Sweatbox
Preview Screenings

Post-Production
SOUND EFFECTS
TITLES AND CREDITS

MARKETING AND DISTRIBUTION

Workflow

orkflow

Pre-Production/Production

While the storyboard artists create a visual outline for the actors/animators, the designers/layout artists are creating the stages for them to act on. This is usually the time when music room scenes are designed by the Layout Department with the Art Director. A music room scene contains no character animation, and is usually a broad establishing shot that gives the audience a chance to get accustomed to the world the story will live in before the acting comes into play.

Production

The Layout Department creates a workbook from the storyboards.

As the production moves to the next step in the Layout Department, the story and film begin to grow. The Layout/Design Department creates the designs, lighting, and camera instructions for the movie. If there are changes, or the camera work is not clear in the storyboards, the Layout Department will create a workbook.

Workbooking outlines the cinematography, which is what differentiates it from storyboarding. Storyboards are created mainly to visually describe the acting. Both of these huge visual documents serve together as an evolving blueprint for movie production.

Different departments in the production process are separate and serve different functions, but are in constant cooperation. Animators are very open to listening to suggestions from Layout, and vice versa. This reciprocation between departments helps Layout to implement ideas into the layout process early enough so there are fewer changes late in the production.

The next step in the workflow process is to give the rough layout and character positions from the storyboards to the animators so the acting can be created on the stage. The Layout artist will discuss each scene with the Animator and adjust rough layouts as needed. The Animator will send the artwork to Scene Planning to create the

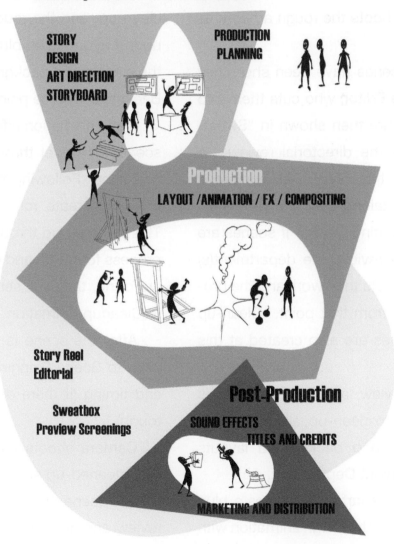

Development / Pre-Production

STORY
DESIGN
ART DIRECTION
STORYBOARD

PRODUCTION
PLANNING

Production

LAYOUT /ANIMATION / FX / COMPOSITING

Story Reel
Editorial

Sweatbox
Preview Screenings

Post-Production

SOUND EFFECTS

TITLES AND CREDITS

MARKETING AND DISTRIBUTION

# Workflow

Production

camera movements and positioning.

Using the information from Scene Planning, Camera shoots the rough artwork as directed.

After the scenes have been shot, they move on to the Editor, who cuts them into sequence and are then shown in "Sweatbox," which is the directorial review. A scene can fail this review for numerous reasons: voice talent, dialogue problems, bad staging, continuity, etc. If scenes are rejected in this review, the department(s) responsible adjusts their work and the process continues from that point. Clean-up and effects notes are also created at this time.

After the review, and if the artwork is approved to go to clean-up, all the artwork, both animation and background layouts return to the Layout Department.

The Layout Department creates a blue sketch combining the rough animation with the rough background layout. The scene is now split in two. The animation with a copy of the rough layout goes to animation clean up, and the rough layout is cleaned up in Layout. The blue sketch along with the cleaned-up background layout goes to Background to be painted.

If any animation effects are needed, the scene will travel through the Effects Department. Following the Sweatbox notes, they will create rough effects animation. This will then go through its own approval process for rough and cleanup. When they are done, they will send the entire packet to Cleanup Animation.

After the scene is cleaned up, it goes back to Scene Planning to finalize camera and timing (if there are changes from the rough).

Camera shoots the cleaned-up scene with cleaned-up effects.

The scene then returns to Sweatbox for review and goes back into the process if it needs final tweaking.

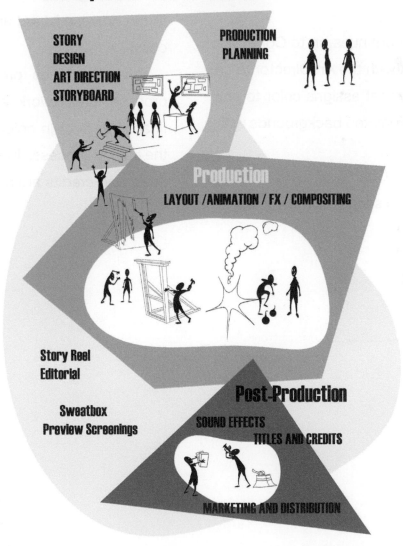

Development / Pre-Production

STORY
DESIGN
ART DIRECTION
STORYBOARD

PRODUCTION
PLANNING

Production

LAYOUT / ANIMATION / FX / COMPOSITING

Story Reel
Editorial

Sweatbox
Preview Screenings

Post-Production

SOUND EFFECTS

TITLES AND CREDITS

MARKETING AND DISTRIBUTION

Workflow

Production

The scene is now ready to be painted and goes to Checking, the department that handles continuity.

The scene continues on to Color Models. They work with the Art Director to create a color key that assigns color to characters with the painted backgrounds within the scene.

On to Final Check. This is the final check before the scene is shot in color.

Sweatbox review…again. If approved, the scene goes to post. If not, it's back to the drawing board and through the process!

As the scenes progress through the process the artwork eventually becomes final, is all shot in color, and goes through the editing process. In Post, sound effects, titles, and credits are added.

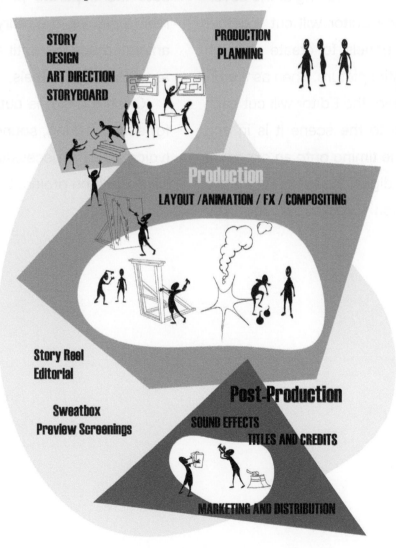

Development / Pre-Production

STORY
DESIGN
ART DIRECTION
STORYBOARD

PRODUCTION
PLANNING

Production
LAYOUT / ANIMATION / FX / COMPOSITING

Story Reel
Editorial

Sweatbox
Preview Screenings

Post-Production
SOUND EFFECTS
TITLES AND CREDITS

MARKETING AND DISTRIBUTION

Workflow

The editorial process operates through the entire production. Starting at the development stage the Editor will cut together the storyboard panels to create a rough timing for the entire picture. Then as the dialogue is recorded, the Editor will cut each piece according to the scene it is in and either transfer the timing onto an exposure sheet or send a digital file to the Animator.

As production progresses and the scenes are shot, the Editorial Department cuts the separate pieces into the show reel, replacing the storyboard panels with animated scenes until all the color pieces are added to the reels.

Once the film is cut together it is time for sound mixing, sound effects, and ADR (voice over) if necessary. The lead Editor will follow the project to the very end.

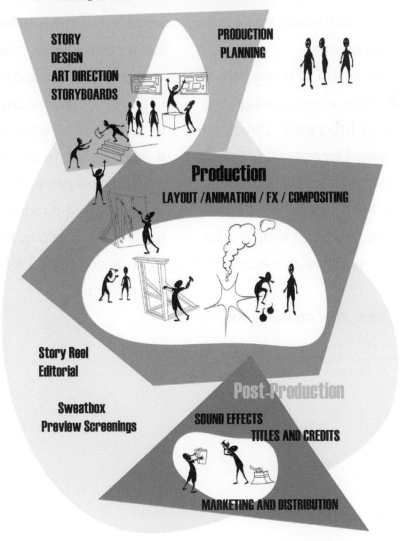

Development / Pre-Production

STORY
DESIGN
ART DIRECTION
STORYBOARDS

PRODUCTION
PLANNING

Production
LAYOUT /ANIMATION / FX / COMPOSITING

Story Reel
Editorial

Sweatbox
Preview Screenings

Post-Production

SOUND EFFECTS
TITLES AND CREDITS

MARKETING AND DISTRIBUTION

Workflow

For the most part, marketing and distribution are usually handled by the distributing studio or another third-party entity outside the production process.

Artists might be asked to participate in promotional and press events (though this is usually limited to Producers, Directors, and Lead Artists). Occasionally, Artists are asked to help create special animation used to promote the film (trailers, partner tie-in commercials, character drop-ins for live-action shows such as the Academy Awards, etc.).

The push for consumer product artwork usually starts right after the characters for the production are "locked" (finalized). Usually an entirely different group of people will do the artwork needed for product, although it will be approved by Directors and Lead Artists before any artwork is released to product licensees for their production. It takes about 18 months to get product to market, and product is usually put on the shelves about a month before the movie is released. Therefore, most of this ancillary work is completed long before the movie is released.

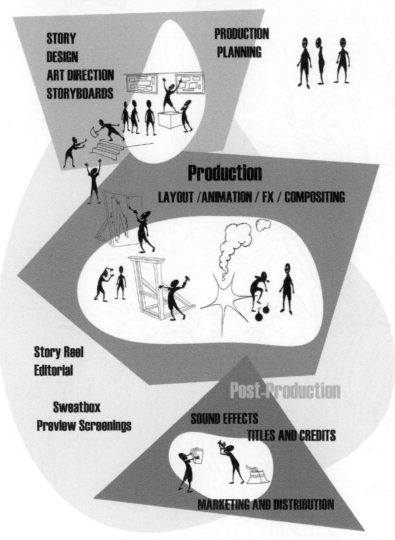

Development / Pre-Production

STORY
DESIGN
ART DIRECTION
STORYBOARDS

PRODUCTION
PLANNING

Production

LAYOUT /ANIMATION / FX / COMPOSITING

Story Reel
Editorial

Sweatbox
Preview Screenings

Post-Production

SOUND EFFECTS
TITLES AND CREDITS

MARKETING AND DISTRIBUTION

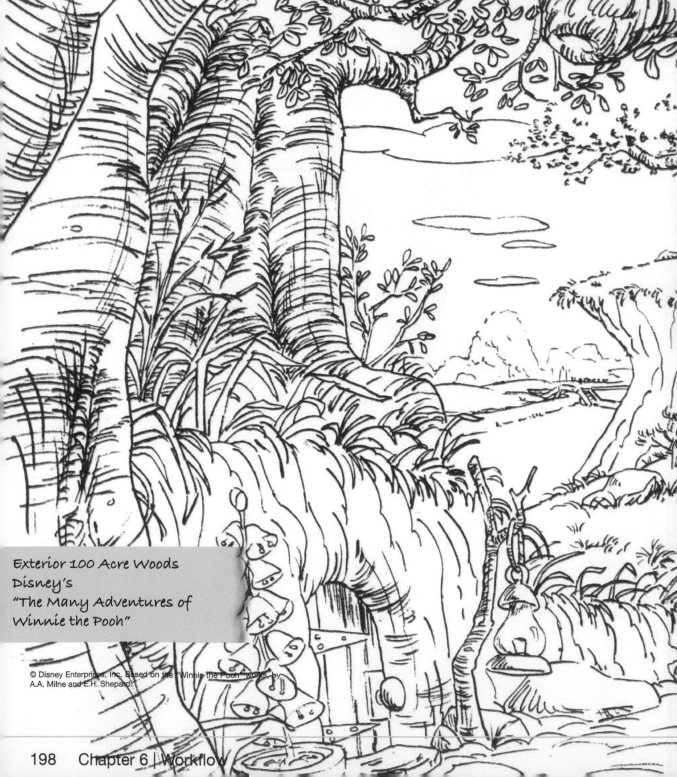

Ghertner's Gallery

Exterior 100 Acre Woods
Disney's
"The Many Adventures of
Winnie the Pooh"

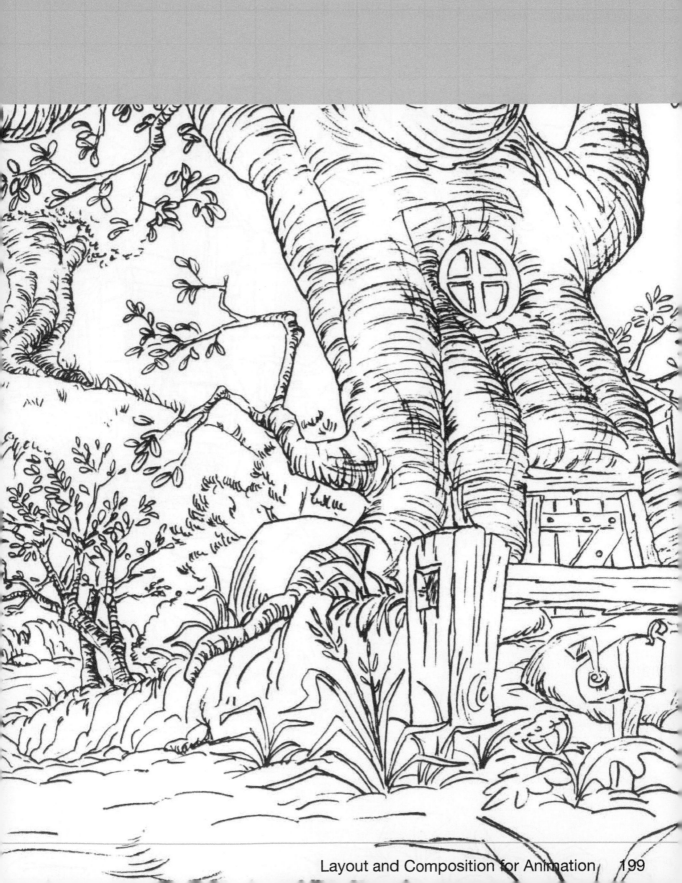

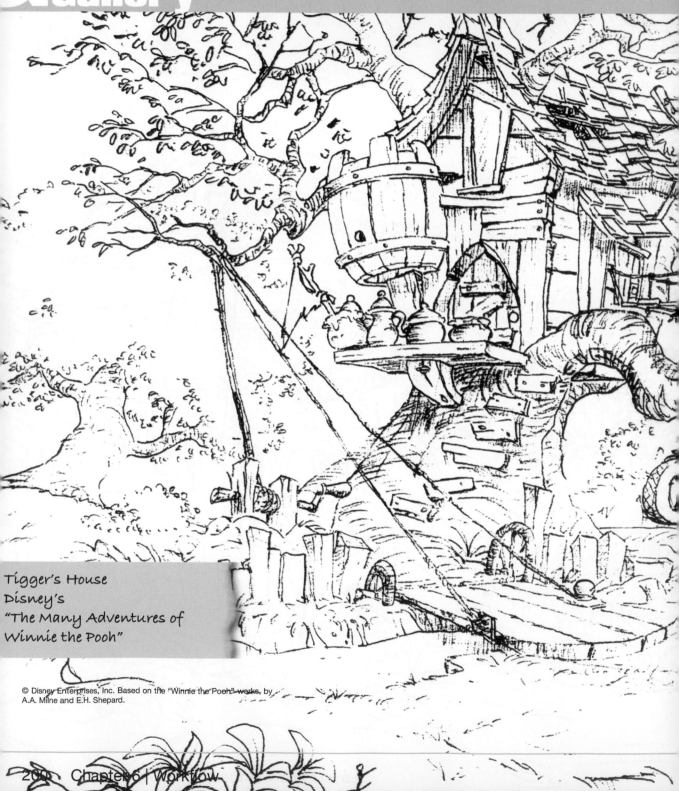

Tigger's House
Disney's
"The Many Adventures of
Winnie the Pooh"

Index

Index